LIGHTING *for* PHOTOGRAPHY

Techniques for Studio and Location Shoots

Dr. Glenn Rand

AMHERST MEDIA, INC. ■ BUFFALO, NY

ACKNOWLEDGMENTS

Parts of this book come from my many years of writing for *Rangefinder* magazine. Because of the great support from Skip Cohen and editor Bill Hurter, this book has been realized. It is also important to recognize the efforts of Craig Alesse, Michelle Perkins, and Barbara A. Lynch-Johnt from Amherst Media. It was helpful to have the support of my friends and colleagues, particularly Tim Meyer, Sam Pellicori, Brooks Institute's students and faculty, the MAC Group, the Mole-Richardson Company, Lowel-Light Manufacturing, Inc., Chimera, and my wife, Sally.

Published by:
Amherst Media, Inc.
P.O. Box 586
Buffalo, N.Y. 14226
Fax: 716-874-4508
www.AmherstMedia.com

Publisher: Craig Alesse
Senior Editor/Production Manager: Michelle Perkins
Assistant Editor: Barbara A. Lynch-Johnt

ISBN-13: 978-1-58428-226-6
Library of Congress Control Number: 2007942659

Printed in Korea.
10 9 8 7 6 5 4 3 2 1

Contents

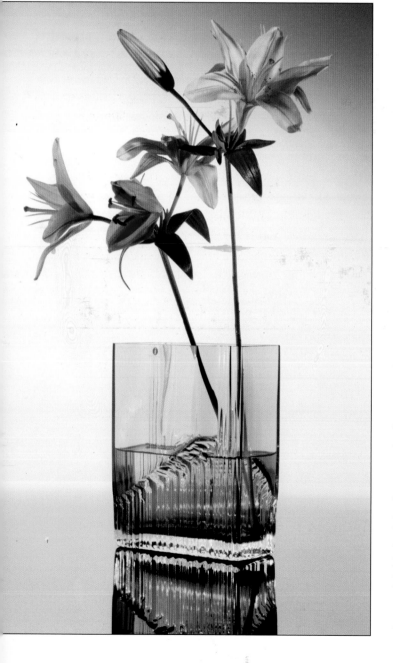

Introduction

Good lighting is the backbone of every excellent image. Though it is true that great lighting cannot, in and of itself, make great photographs, bad lighting will surely ruin photographs. Therefore, we must avoid bad lighting. This fact is applicable to film photography and digital capture alike.

A colleague and early digital photography teacher, Ike Lea, said many years ago, "Bad lighting with digital imaging is still bad lighting." His point was clear—we tend to think that digital imaging can be used to correct errors introduced during capture. Unfortunately, if lighting is bad, post-capture correction can do little but cover the faults. It cannot correct poor lighting.

ABOUT THIS BOOK

In this book, you will learn about the tools that are used to create and control photographic lighting. The discussions presented in these pages go beyond advice for avoiding bad lighting. This book takes a stance that the more you know about the basic functions and potentials of light, the better your photographs will be. Though many books take a genre-specific approach to

This image was made for a promotional piece for the Jackson Symphony Orchestra. The lighting allowed a one-second exposure to show the motion of the cello bow and the violin in the background. Contrast control was used along with post-capture processing to eliminate the background. Photograph by Glenn Rand.

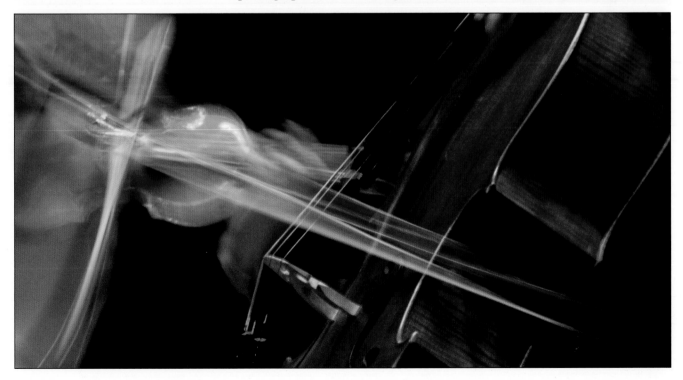

lighting, this one covers the hows and whys of light and lighting. We'll look at techniques that can be used to produce good lighting in the studio, where you have control over the light, as well as in outdoor environments, where you are at the mercy of nature. Rather than a series of "cookbook" solutions that work only in certain situations, you will learn a broad-based approach that you can rely on time and again to produce exquisitely lit images.

This book includes a comprehensive discussion of everything from the language used to describe light, to its qualities and characteristics, to the means of controlling light. You'll also learn how to use light to define the shape of your subjects for enhanced artistic control. Lastly, you'll learn techniques for lighting challenging subjects.

In each section, you'll find images and captions that will enhance your understanding of light and lighting. You'll learn why a particular lighting strategy was chosen and will also be able to study diagrams that show how the lighting patterns go together.

With these tools at your disposal, you'll learn to harness, supplement, and modify light to produce the best-possible photographs of your every subject, time and again.

1. The Language of Light

Turning off the lights is like using the mute button for our visual language.

Turning off the lights is like using the mute button for our visual language. Light makes photography possible. Without light, film and digital image sensors cannot record images. Though light is required to record any photographic subject, it's important to note that its careful application can enrich the visual story. In certain light, for instance, we might see the overall shape of a car. When that same subject is carefully and artfully lit, the interplay of shadows and highlights will build a much richer story—we can perceive that the car is red and shiny. We can appreciate the qualities that make it a standout subject. In this way, expert lighting creates a visual story in much the way adverbs and adjectives are used to enrich a written story.

KEY CONSIDERATIONS

In the following paragraphs, we will look at three critical concepts that we must embrace to effectively light our subjects.

Highlight and Shadow. Film and digital image sensors respond to light, not darkness. When we look at a scene, we need to look more closely at the light and the way it highlights the positive aspects of our subject. We should strive to capture light tones with detail, which provides visual information about our subject. We should be aware that blown-out highlights and blocked-up shadows (pure white or black areas that lack detail) can detract from the quality of the overall image. It's important to note, also, that when working digitally, you must expose for the highlights, as digital imaging is not as tolerant of overexposure as film.

To better understand the impact of highlight and shadow on our perception, consider the following:

In the image on page 8, we have a sketch of a box, drawn in white against a black background. If you were told that there was light falling upon the top of the box from the left-hand side and were to shade the drawing in a way that depicted the light's impact on the scene, what would your drawing look like?

Most people who have done a little drawing in their lives would fill in the shadow area with as much white chalk as they could. They'd put almost as much chalk on the right face, since it would also be in the shade. They'd figure that the left face receives some light and would color it lightly. This proves that we are brought up to see and draw shadows. We tend to think of shadow

YOUR MESSAGE

The manner of your speech, the number of languages you know, and your skill in using the language mean little if you have nothing to say. The same holds true in photography. Be sure your subject is worthy of a photograph and carries a message that will appeal to viewers.

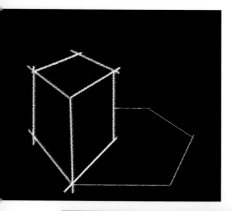
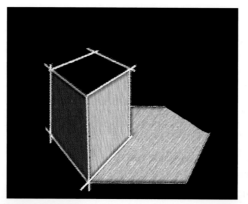
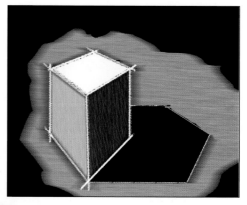

areas as the active part of the scene and the light as the unseen. This would be more accurate if we were drawing with black on white paper.

If we filled in the light intensities rather than the shadows, we would create the illustration at the top right of the page. The ground would be light and the shadow would not be colored in. Since the light is coming down from the left, the top would be given the most chalk and the left side would get the next most density. The right side would be given the least density. The final illustration shows a visual space more like photography.

Light is Light. All light, no matter its origins, follows the laws of physics. Controlling that light in any situation, whether you're confronted with natural light, incandescent light, electronic flash, or a mixture of sources is your goal, as it will help you to render the subject in a way that suits your creative vision.

The following story illustrates the fact that a solid understanding of lighting can help you produce the best-possible images in a variety of situations.

Some time ago, I was assigned to photograph the artwork of Nodo Fujimoto, a Japanese National Living Treasure. I was told that I could use the museum's lighting equipment. When I arrived, I found that the studio was not set up for photography. There were fifty or sixty pieces of lighting equipment, but they had no working lightbulbs or flash tubes for any of their equipment. There was also a large window that could not be blocked, and

that made the photography even more challenging. Since the
was already scheduled to be featured on a magazine cover, I ha
but to take the image.

It was decided that I would photograph the subject in an offic
be cleared enough for us to build a small set. We needed access
yond the fluorescents in the room. Common incandescent floo
used to light the exterior of the building, and these were acquirec
subject. Realizing that the light would function the same rega
source allowed for the completion of the assignment. Using bloc
and diffusing the light, I was able to capture a workable ima
checker chart was included in one of the images, and when the
cies were separated, the lab technician was able to balance the li
rect the color. Needless to say, on the cover of the magazine, t
evidence of how the image was produced—only that it accurate
the ceramic art.

Photographing Lighting, not Light. Last, we need to c
though the quality of the light might draw our attention to a

*Realizing that the light would
function the same regardless of
the source allowed for the
completion of the assignment.*

Transmission, reflection, or scatter of the light modulates all lights and objects seen in this image. None of the light sources can be seen directly without interference. Photograph by Glenn Rand.

subject of the image is rarely the light or lighting itself. In thinking about lighting, we must concern ourselves with how the light will affect the subject. Will it improve the subject's look or diminish the appeal of the photograph? Is the subject in the beautiful light something we wish to photograph?

Light we encounter as we look at various objects in our daily life might be something we wish to simulate in the studio. In this case we need to observe what it is that created the superb light and the feel it created. We need to create light that will affect the subject in the way we wish.

THE EMOTIONAL IMPACT OF LIGHT

Our verbal language is comprised of words that have distinct meanings. The visual language sets a mood that changes the way we interpret the scene. Light is not the subject, it only augments the subject and its meaning.

Drama. We become familiar with the emotional component of light at an early age, through television, theater, and printed media. For instance, we know that drama can be created with lighting. We think of theatrical sets with harsh, angular light creating a sense of foreboding or tension. Think of a scene in which an individual is standing under a streetlight. The lighting is harsh, contrasty, and focuses the viewer's attention on the subject.

The colors within and between the lights in the scene can enhance the sense of drama in a scene. Red lighting will create a feeling of heat, and light

We need to create light that will affect the subject in the way we wish.

The bright, contrasty light heightens the drama in the image. Photograph by Glenn Rand.

The soft light coming through the stained glass and the diffused surface of the stone creates calm light. Photograph by Glenn Rand.

When a color contrasts with other colors in the scene, dissonance results.

with a bluish cast will impart a cold feeling. When a color contrasts with other colors in the scene, dissonance results. This may lend an anxious or tense feel.

Calm. The lighting used in the scene can reduce tension and promote a sense of calm. Light falling softly through a canopy of trees is comforting. Open shadows and subdued highlights are soothing. This type of lighting places less stress on the perceptual system than does high-contrast lighting.

The color of the light will also affect the sense of calm in the scene. Green tends to create a feeling of calm in an image as do soft, pastel colors. When the color of the light in the scene complements the color of the subject, the subject's color will appear more dull and the feeling of calm will be enhanced. In a scene in which the light and subject color are similar in softness, the calming effect will be greater still.

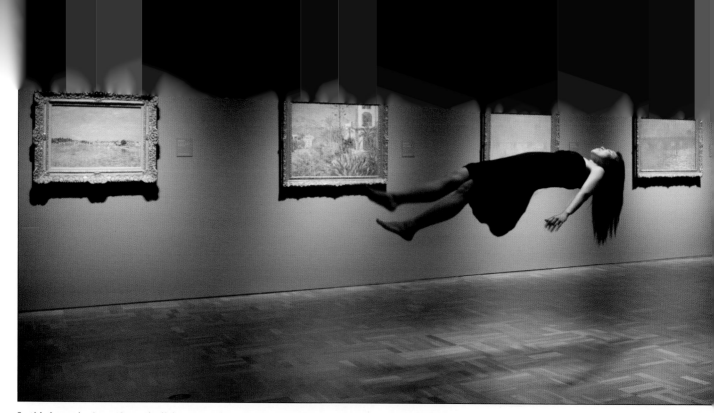

In this image by Aaron Corey the light creates drama in two ways. First, the isolation of the paintings on the museum's walls sets an overall mood for the image. Second, the shadow created on the floor below the floating girl adds mystery to the image.

"Dispassionate" Light. Light can also be dispassionate. When the light is bright with no noticeable shadows, it is flat, colorless, and not helpful for creation of bold shadows, oversaturated colors, dissonance, or tension. We think of this light as sterile.

Natural Light. Though we have focused on the emotion that can be created in the studio or in theatrical settings to this point, it is important to note that it is also possible to observe this emotional quality of light in nature. In fact, we frequently replicate the light found in nature for use in our indoor sessions.

The sky conditions and the sun's angle determine, to a great degree, the feel of the light we use in our photography. When the light is produced from the bright clear sky at sunset or sunrise, it is dramatic. As the light reddens with the sun close to the horizon, the light is warm and the sun's angle creates long shadows and definite texture that add to the drama of the light.

During midday, the light loses its drama. If it is broken up by haze or very light overcast, it becomes dispassionate or flat. Particularly, when the light is behind the camera and high in a hazy sky the lighting becomes very sterile. When the sky is overcast, the light is calm—unless the sky is very dark and foreboding. This is true regardless of the time of day.

The feel of the lighting is due, in part, to the fact that the eye seeks to average the light range in the scene. When a scene contains a very bright light source and there is little other light reflecting from subjects within view, there is a high contrast. Looking for detail in the darker areas requires more work, and therefore, the scene creates tension. The opposite is also true: in a calm

We frequently replicate the light found in nature for use in our indoor sessions.

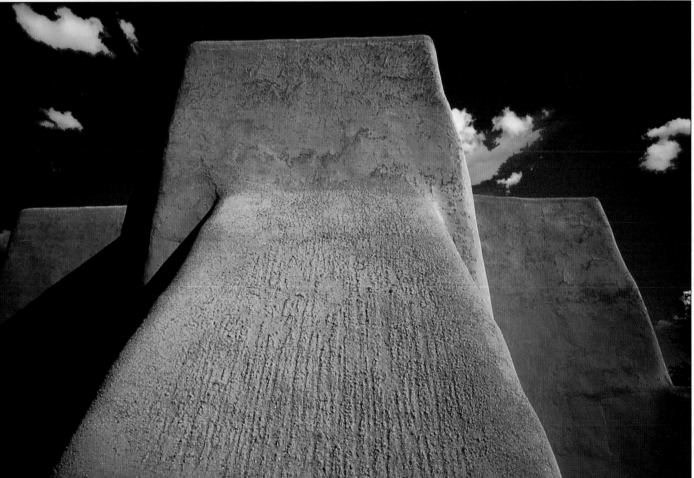

The bright sunlight, dark sky, and deep shadows create a dramatic look with strong texture in the adobe. The abstract image is made stronger with the specular light. Photograph by Tim Meyer.

The image was made with a diffuser panel over the set and a small kicker on the left side that added some of the specular highlights and illuminated the Italian flag reflected in the black Plexiglas. Lansing Community College student project by Andrea Aurnold with G. Rand.

light situation, the lighting is softer or the light source is broader. The light values that need to be averaged by the eye are closer together. This lighting situation is easier for our perceptual system to deal with as we view the scene.

Low Key and High Key. When the light levels in the scene are predominantly dark or near black and there is little detail information above middle gray, the scene is considered low key. When the light levels are predominantly bright and the image tones are light or near white with little information below middle gray, the scene is considered high key. Low key lighting tends to be seen as foreboding, and high key is viewed as cheerful.

SEVEN LIGHT QUALITIES

Though the quality of light will be discussed in detail in chapter 3, it is important to note that the quality of light is an important part of the language of light. There are seven qualities that are addressed when talking about light—(1) its specular or diffuse nature, (2) intensity, (3) direction, (4) how shadows are developed, (5) the color of the light, (6) contrast, and (7) how the light fits the capture medium. These qualities give us a sense of what the light is and, more importantly, how it will be used to make a photograph.

2. Light Creation and Optics

Light is the energy that makes photography possible. The way it is produced determines, to a great degree, what you can do with the lighting. It also plays into the design of the equipment we use and impacts our ability to control or modify the light. Light can be produced by myriad sources.

INCANDESCENT LIGHT
Sun. Incandescent light is most easily described as light produced by a hot source. The sun is the hottest, most readily available and most often used in-

This image by Cynthia Lespron shows the effect of reflected light energy. The image was made with an infrared camera. The infrared energies reflect from the grass but do not reflect from the hoofprints.

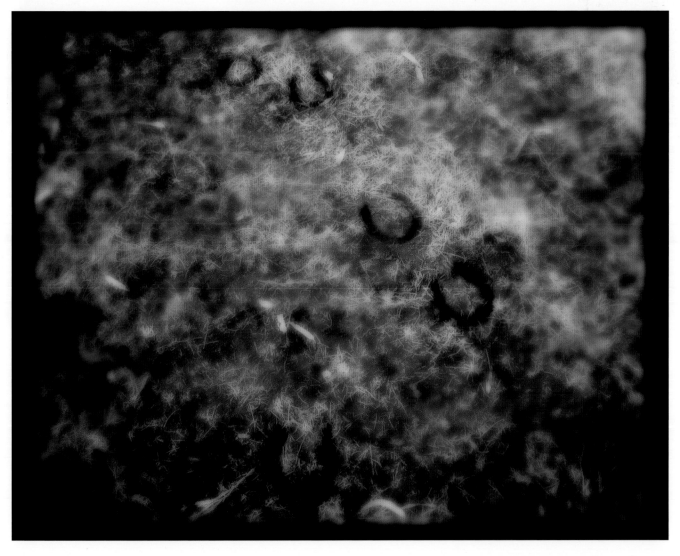

candescent source of light for photography. The majority of the light that reaches the earth falls into the visible range of the electromagnetic spectrum. Other parts of the electromagnetic spectrum are absorbed or reflected by the atmosphere.

Artificial Types. Another common incandescent light source is the electric lightbulb. Though these are available in a variety of types and intensities, all generate light in the same way. The glass bulb is filled with an inert gas and a fine, doubly wound tungsten filament. This double winding allows the filament to have a very small cross section while maintaining a reasonable size. Each end of the filament is attached to the electric contact. As electric energy passes through the filament it heats up to the point it emits light as well as heat. At about 1900° Kelvin (K), or approximately 1650°C or 3000°F, the filament will start to emit red light. As the filament gets hotter the light emitted changes from red to yellow to blue-white. This is known as the light's color temperature. The most commonly used photographic incandescent bulbs have color temperatures of 3200°K (quartz-halogen bulbs) and 3400°K (photofloods).

The inert gas keeps the filament from oxidizing and/or burning as it gets hotter. However, the energy being forced through the filament causes some molecules of the tungsten to be dislodged. As a result, the filament's cross section becomes smaller, and that in turn makes the filament generate more heat and changes its color temperature. Since the color temperature will change long before the bulb fails, photoflood bulbs are rated for the time that their light remains a constant color temperature. If this process continues, the filament will eventually become so thin that it will break. This may cause a flash as the filament separates and there is an arc of electricity.

To solve the problem of the ever thinning filament, a small envelope is created with a halogen gas, most commonly iodine. The term envelope refers to the enclosed shape of the glass bulbs containing the element. As the system gets hotter the iodine interacts with the molecules of tungsten that have been shed from the filament. This tungsten-iodine amalgam is attracted to the electrical current passing through the filament. When this happens the ejected tungsten is deposited on the filament keeping it from losing cross section dimension and giving the bulb longer life.

However, to have the chemical reaction function, the heat in the envelope must be high, and this changes the requirements for the bulb. To allow the buildup of the heat a quartz glass must be used. This is why these bulbs are called quartz lights. Though the quartz glass will not melt at the operating temperature of these bulbs, the skin temperature of the bulb is very close to its melting point. Therefore, any foreign materials on the surface can create a heat sink or a flux, either of may cause the glass to melt at that point. If there is a melting spot on the bulb, the bulb may become deformed or explode. For this reason, it is important not to touch the bulb's glass when cool.

The glass bulb is filled with an inert gas and a fine, doubly wound tungsten filament.

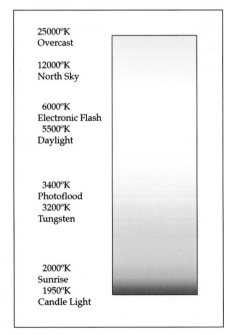

This scale shows the color temperature of various light sources used in photography.

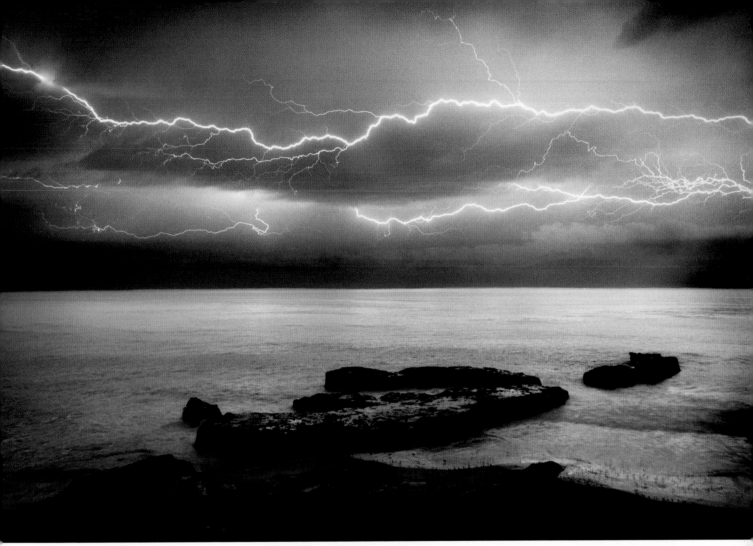

Lightning is nature's electronic flash. As seen in this photograph by Patrick Stanbro, an electronic charge travels through the air and, as it does, it creates a discharge light.

Light-emitting diodes (LEDs) are a commonly used discharge source.

DISCHARGE LIGHTS

Some units output light by the discharge (release) of energy.

LEDs. Light-emitting diodes (LEDs) are a commonly used discharge source. These units generate light by releasing energy that has been applied to a diode. The application of the energy to the diode reverses the polarity of the diode, and when the diode reverts to its original polarity energy is released in the visible spectrum. Other LED types include OLEDs (LEDs made of organic material), FOLEDs (flexible organic light-emitting diodes), and SOLED (stacked red, green, and blue LEDs), which generate color.

HMIs. Metal halide lamps (HMIs) create light by discharging an electric current through a small gap between electrodes. The arc produces heat and pressure in the envelope and in turn this vaporizes the metallic atoms in the bulb. When the atoms vaporize they emit electromagnetic energy within the visible spectrum.

Gas Discharge Types. Using inert gasses, such as neon or xenon, and passing an electric current through them also creates discharge light. As the electric current passes through a tube filled with the inert gas, energy is absorbed within the atomic structure of the gas. This happens when electrons move into a higher energy state. When the energy is withdrawn from the atom or has passed through, the electron returns to its original energy state

and the gas glows. Neon lights stay in their glowing state while the light is turned on. Electronic flash units, on the other hand, use a capacitor to hold a large charge that can be released into the xenon gas at one instant and will have a short duration. The amount of light and duration of the burst of en-

COLOR TEMPERATURE

Different types of light have different color temperatures. The temperatures are related to a black body (a theoretical incandescent source) that produces heat and light as it absorbs energy. As the heat increases, the color goes from a dull red and continues to white-hot. The white actually has a blue bias.

Non-incandescent light sources have a discontinuous or combination spectra, or a highly unbalanced spectral energy distribution. The apparent color temperature of discontinuous spectral lights places light sources on a red–blue scale using the Kelvin scale used for black body temperatures.

Another way to describe the difference in the output of various light sources is to look at the spectral makeup of the light. We can understand the color bias of the light by examining the spectral energy distribution (SED) graph. This compares the amount of energy (vertical direction) measured at specific wavelengths (horizontal direction). If the graph is high in one wavelength area of the spectrum, the light will have that color bias.

When working with film, photographers use filters to balance the light to suit their selected film. Photographers working digitally use software built into the camera to adjust the way the color of the light is rendered or make the required adjustments in postproduction using image editing software.

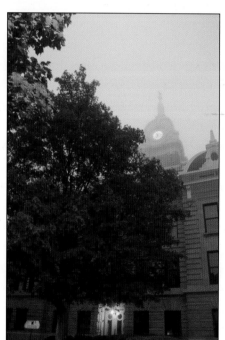

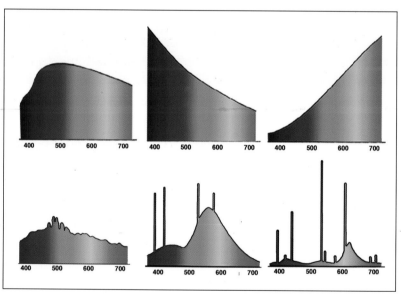

Left—This image shows three different light sources. The sky and most of the building are lit with natural light passing through fog. The fog shifts the light's color temperature higher, illuminating the building and sky with a blue cast. The doorway and clock face are illuminated with incandescent light, giving these areas a yellow color basis. The incandescent bulb visible in the doorway appears white since the energy from the bulb is beyond the sensor's ability to differentiate tones. In the foreground, a low-pressure sodium vapor light produces the pinkish bias light that illuminates the trees. Photograph by Glenn Rand. **Right**—The six spectral energy distributions show the color balances of different light sources. The top row shows three continuous spectra from daylight, North sky, and tungsten light. These have color temperatures of 5500°K, 12,000°K, and 3200°K respectively. The lower row shows the spectral distributions of combination spectra for electronic flash, fluorescent, and HMI light sources. Their apparent color temperatures are 6000°K, 4500°K, and 5000°K respectively.

ergy is related to the amount of charge released from the capacitor. The larger the discharge, the brighter the flash and the longer the light's duration.

The color of light depends on the type of gas in the light tube. The color temperature of the glow is approximately 6000°K when xenon gas starts to warm up, allowing for the use of daylight film or the daylight white balance setting on a digital camera, but the color temperature changes as the light cools down. Because of this cycle, some manufacturers have implemented controls that use only part of the cycle and thus change the color temperature below the maximum known value of the flash unit.

LUMINESCENCE

Luminescence is the glowing of a material that occurs when it absorbs an energy source and then releases light. Fluorescent lamps operate this way. An electric charge is passed through a low-pressure atmosphere of mercury. The electric charge releases ultraviolet energy from the mercury vapor; this hits the surface of the tube, which is covered with a phosphor that emits visible light when excited by the ultraviolet energy. Most fluorescent lights have a green color bias because of the mercury vapor light that is used to cause the glow of the phosphors. Fluorescent light can be balanced for use with daylight film and an FLD filter or by white balancing a digital camera.

OPTICAL INTERACTIONS

Light interacts with the elements in the environment through absorption, reflection, refraction, dispersion, scattering, diffraction, and polarization. In the paragraphs that follow, we'll look at the ways in which these interactions affect the light and impact our photography.

Transmission and Absorption. When light strikes an object it passes through it (e.g., in the case of transparent or translucent object) or is absorbed. In some cases, the color and density of an object will absorb some wavelengths of light and transmit others. When light strikes clear water, for instance, red wavelengths are absorbed and we see the cyan wavelengths, which appear light blue.

This is the principle at play when using photographic filters. When a red filter is placed on the lens, for instance, only the red wavelengths are transmitted, and the other wavelengths of light are absorbed.

The amount of absorption is dependent on the tone, color, and type of the material used.

The amount of absorption is dependent on the tone, color, and type of the material used. As a general rule the darker, more saturated, and denser the material, the greater the absorption of the light. As the colorant approaches black, the material absorbs a higher proportion of the energy from the incident light. This can actually be felt if you wear a black shirt on a sunny day. The black material absorbs the energy of the sunlight, which you will perceive as heat.

Reflection. Reflection is the primary way we see objects. As light interacts with a surface, a portion of its energy is reflected. When the surface is smooth

or polished, the reflection of a point source of light will appear as a hot spot. When the surface is textured, the reflected light is spread out and diffused. This is the principle behind non-glare glass. When the surface is not planar the reflections will be irregular or distorted.

Though most of the light that strikes glass will be transmitted and/or absorbed, a small amount will be reflected. The percentage of reflection depends on the composition or surface of the glass. Only about 4 percent is reflected from common glass; that means that about 96 percent of the light is transmitted or absorbed.

The percentage of reflection depends on the composition or surface of the glass.

The most important principle used in lighting is that the angle of incidence (i.e., the angle at which the the light strikes the reflective surface) is equal to the angle of reflection. The angle of incidence and angle of reflection are measured from a perpendicular at the point where the light strikes the surface. The perpendicular is used so we can take into account a surface that is not flat.

A reflection can occur whenever light intersects with a change in medium. It is most noticeable when light interacts with a visible surface such as a solid

Left—The original scene was a light-green bush in a red rock formation. A green filter was used over the lens. Because there is green in the light coming from the bush and no green coming from the rocks, the filter allows more of the light reflecting from the bush to reach the black & white film than the light reflecting from the rocks. This makes the light from the bush appear brighter than the light reflecting from the rocks, thereby increasing the contrast in the image. Photograph by Glenn Rand. **Facing page**—The water's surface reflects the light from the sky showing the dark areas where light has been blocked by the trees. The waterlilies are lit by the light passing through the trees. Since the sun was from the camera side of the scene, direct sunlight reflected back and away from the subject, eliminating speculars on the water. Photograph by Glenn Rand.

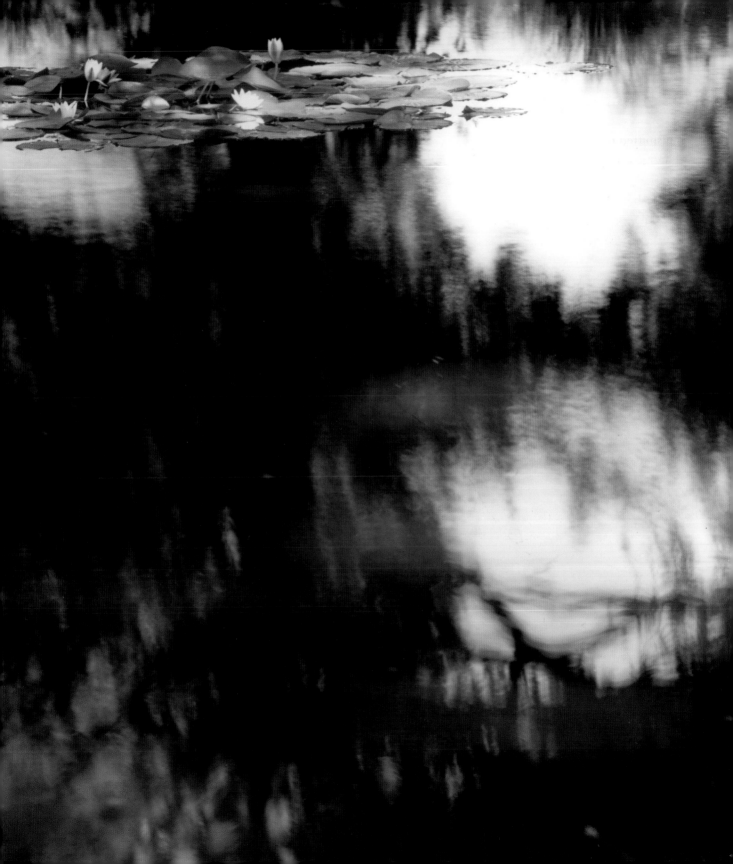

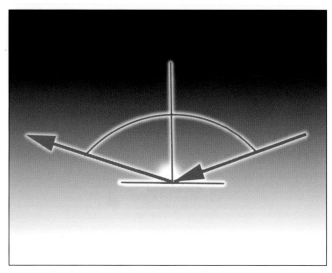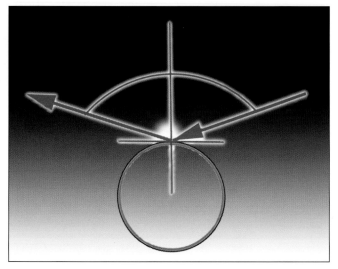

The Law of Reflection states that the angle of incidence and the angle of reflection are the same. Both angles are measured from a perpendicular at the point where the light strikes the surface. When working with a non-planar surface, the perpendicular is defined as a line originating at the center of curvature and passing through the point where the light strikes the surface.

material, glass, or the surface of liquid, but it can also occur if there is a density difference between two gasses. These reflections occur on both sides of the change in material.

Reflections occur on the camera-facing surface of a wine glass or on the inner surface of the glass with the light passing through the wine, or within the glass itself. A phenomenon known as internal reflection can keep light passing through a surface and is important in underwater photography. If light strikes the undersurface of the water with a great enough angle of incidence, all the light will reflect. It will not transmit back through the water's surface.

Refraction is the bending of light as it passes through materials of different densities.

Refraction. Refraction is the bending of light as it passes through materials of different densities. When the light moves from a less dense medium to a denser medium (e.g., from air to glass) it bends toward the perpendicular where the light strikes the denser medium. When the light moves from a denser medium to a less dense medium, it bends away from the perpendicular. Because of these two refractions, when light passes through glass with parallel surfaces the light exiting the glass will be at the same angle as the incident light.

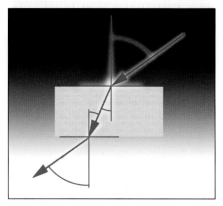

The angle of refraction, once the light enters the glass, is diverted toward the perpendicular because the glass has a higher refractive index than air. As the light exits the parallel surface of the glass into the air it refracts to its original angle.

In this image the light reflecting from the flowers behind the wavy glass is refracted and distorted because the two surfaces of the glass are not parallel. The reflection of the sky is brighter than any of the light passing through the window, obscuring much of the light in those portions of the image. Where the light from behind the glass is brighter than the reflections from the buildings opposite from the window the flowers show through. Photograph by Glenn Rand.

With shorter wavelengths (e.g., violet, blue, etc.) there is a greater degree of bending.

The amount of refraction that occurs depends upon three factors: the relative refractive indices of the two media, the angle of incidence, and the wavelength of the light. With shorter wavelengths (e.g., violet, blue, etc.) there is a greater degree of bending. Less bending occurs with longer wavelengths (e.g., yellow and red). This is why many lenses feature a separate focus point for infrared wavelengths, which are longer than red light.

Without refraction, lenses would not function. Though the light's direction is restored with parallel surfaces on the glass, the light changes the amount of refraction when leaving the glass if the surfaces are not parallel. When the lens surface is convex, the refraction concentrates and focuses the light; if the lens is concave, the light will spread. Both types of lenses are used in combination to control the focus of the camera.

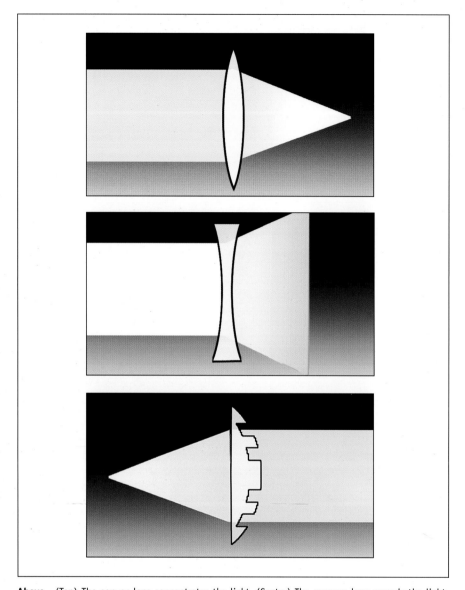

Above—(Top) The convex lens concentrates the light. (Center) The concave lens spreads the light. (Bottom) A Fresnel lens is commonly used in lighting equipment.

Lenses are also used in lighting equipment and in enlargers. A Fresnel lens is used to gather and focus into a single beam the rays of light output by the source. Fresnel lenses are lighter than conventional convex lenses of equal focusing power. In the darkroom, Fresnel lenses are used to focus the light used by condenser enlargers.

Flare. As light enters the lens most of the light is refracted and focused. However, a small portion of the light can reflect off the lens elements, filters, and interior surfaces of the camera. If the light is very bright, some of it may reflect back toward the film or sensor and be focused. When this light comes from a strong point source, polygons of light in the shape of the iris will appear in the image.

Often it is incorrectly assumed that lens flare is created only by direct, strong light sources such as the sun. However, all light creates lens flare. Dif-

Fresnel lenses are lighter than conventional convex lenses of equal focusing power.

fuse light striking the lens creates a diffuse pattern of light intensity across the image-capture surface. This blurred light pattern affects the shadow and highlight areas of the image. When this intensity is added to the dark areas of the image it removes the richness, and the added light in bright areas of the image eliminates highlight detail. This reduces the contrast in the image. The loss of contrast, in turn, results in a reduction of sharpness and a decrease in color saturation throughout the image.

Special lens coatings and special types of glass can be used to reduce lens flare, but it is usually present to some extent. Keeping non-image-forming light from reaching the lens will improve the image quality. The easiest way to accomplish this is to use a lens hood or a matte box. The black matte interior of the device will reduce the light reflecting into the lens from any angle. In the studio, gobos and flags can be used to keep extraneous light from reaching the lens.

Keeping non-image-forming light from reaching the lens will improve the image quality.

Dispersion. As white light strikes a glass surface, the various wavelengths (i.e., colors) refract at different angles and are separated (dispersed). If the light emerges through a glass surface that is parallel to the entry surface, it will remix to its original light color. If it emerges through a surface that is not parallel to the entry surface, the light will be further refracted and dispersed (i.e., separated). This is the way in which a prism separates white light into a spectrum.

Polarization. When light travels from the sun and various other sources, the light waves are unpolarized. In other words, the wavelengths vibrate in a variety of directions.

When light is reflected off nonmetallic surfaces, such as glass or water, it will take on a polarity that is aligned with the surface's orientation and po-

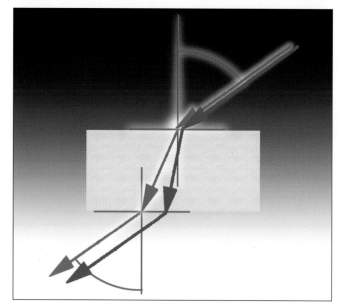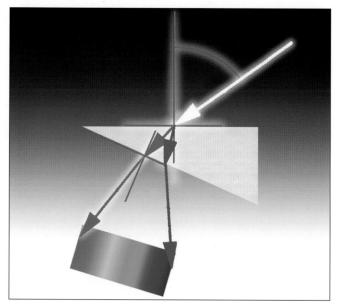

Red and blue light are refracted at different angles. If both enter the glass at the same point and exit through a parallel surface, both will revert to the angle of incidence, but they will be separated (dispersed). If the exit surface is not parallel to the entry surface, the light will be further dispersed. To visualize this, imagine the way that light entering a prism is split into a spectrum.

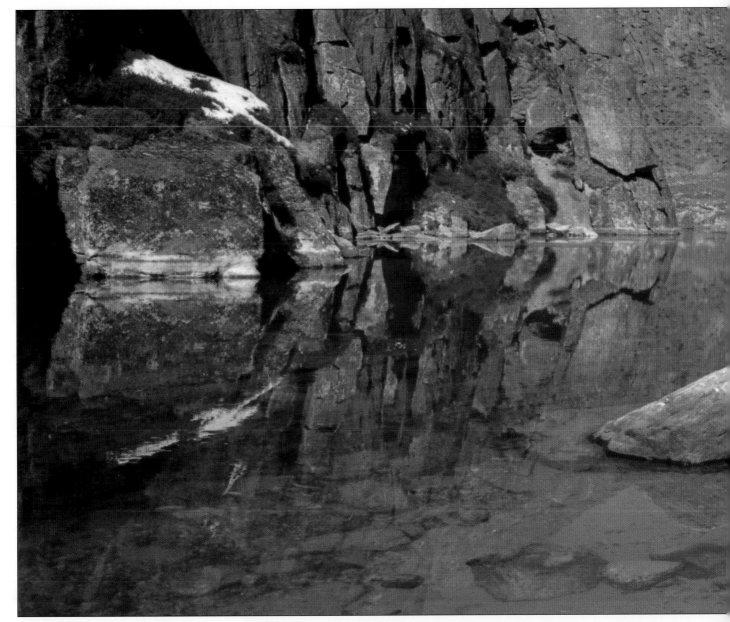

Andrea Bachand Meyer used a polarizing filter to create this picture of a Nepalese lake. This allowed for the recording of the details of the shallows of the water. Without the polarizing filter the reflection of the sky would have been too powerful, and the detail under the water would have been obscured.

larized reflections will result, producing unwanted reflections or glare that can diminish the overall quality of the image. To discourage this effect and make subjects photographed through glass or water more visible, polarizing filters are used. These filters, made of micro-metallic crystals arranged in parallel lines or concentric circles, allow only light at specific orientations to pass through the lens. Linear polarizing filters are more effective, but with modern auto focusing systems, concentric circled polarizer filters are required.

Diffraction. Diffraction describes the change in direction and intensity of light as it passes through an aperture, diffuse surface, or other obstacle. The diffraction deviates the light's path, and the closer together the edges or fea-

tures that are diffracting the light, the more apparent the effect. Longer wavelengths (e.g., red) diffract more than shorter wavelengths (e.g., blue). It is important to note that light diffracted as it passes through a tiny lens aperture can cause color fringing.

Scattering. When light interacts with a transmitting material, a reflective surface, or even particles in the air, its wavelengths are reflected or refracted and the light becomes more diffuse.

Outdoors, as light moves through fog, haze, or smoke on its path from the source to the subject, it is diffused. The denser the material through which the light must pass, the more diffuse the light. Very dense scattering makes the light take on aspects of a larger light source. As the light spreads, some of its intensity will be lost. Since shorter wavelengths can be bent more than longer wavelengths, placing a UV filter on the camera can reduce the effects of haze without affecting the light's impact on the subject.

Light between the subject and the camera may also be scattered, and the diffused light may make the subject appear softer. When the light source is coming across the subject-to-camera axis, the subject is more visible than when the light is on or near this axis. This is because when the light source is from behind the camera the particles in the air reflect the light back at the camera, thereby lightening the image. If the light is behind the subject, silhouetting occurs and detail is lost in all areas of the subject. Also, the scattered light coming toward the camera further diffuses the image with bright light.

When fog, smog, haze, etc., are present in the scene, we are faced with a condition called *aerial perspective*. This results in a loss of detail, color satu-

Though not a function of diffraction, shadows created with lighting equipment give a falloff characteristic that can be confused with diffraction. This is the effect of the penumbra (the shadow falloff) created by the size of the light source's surface and the angular component of the light striking the blocking device.

The light from the spotlight is partially blocked by a barn door. Note the straight edge of the right side of the light form projected on the background. The softness of the edge is due to the transition from the light, through the penumbra, and finally to the umbra (the full shadow). The falloff created by the barn door's edge is known as feathering. Note too the falloff through the rest of the light pattern. The light intensity is brightest at the circle of illumination of the focused light and decreases beyond that point.

An image sensor is made up of very small pixels, each with its own color filter. If wavelengths are diffracted as they pass through the iris of the lens, color fringing (also called *chromatic aberration*) can result. Note the color fringes in this digital image, red to the bottom and cyan to the top. Color fringing is more common on the outer portions of images made with wide angle or zoom lenses. Photograph by Glenn Rand.

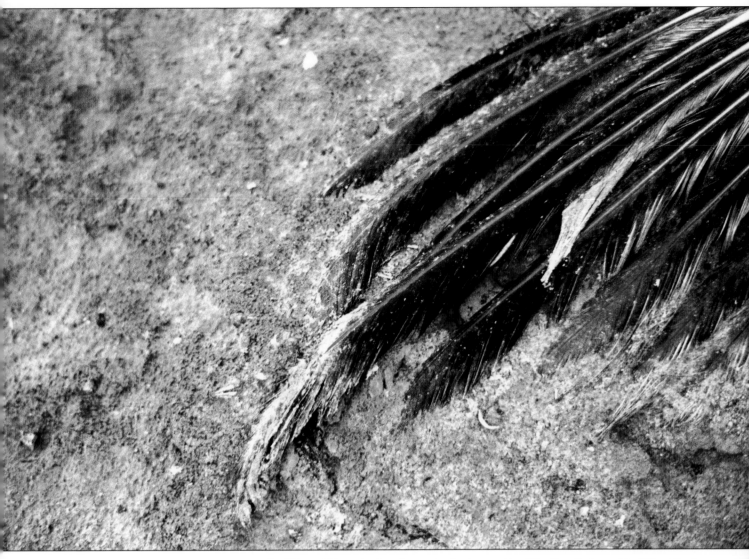

The iridescent blue color from the crow's wing is caused by diffraction. Photograph by Michael Rand.

ration, and/or tone as parts of the image recede into the picture space. Aerial perspective creates a strong sense of depth and can produce a layering of densities when similar tones are in the scene, such as a forest or cityscape. Water absorbs red wavelengths of light and, therefore, as objects recede into a humid scene, whether fog or haze, their color shifts to a bluish coloration. This is actually described in the song *America the Beautiful* with the words "purple mountains' majesty."

When we wish to record a path of light in an image, scattering is critical.

When we wish to record a path of light in an image, scattering is critical. The particles in the air, dust, humidity, etc., scatter the light as a beam passes through, reflecting some of the light toward the camera and producing the visible light pattern that is recorded.

The scattering of light can also allow us to capture some motion effects. When materials like acetate, gauze, or water move between the subject and the camera the light reflecting from the subject is disturbed and multiple overlapping distortions will result. Due to the path of the motion the scat-

tering may not be as random as the scattering created by a uniform material such as fog.

In the studio, softboxes and reflectors are typically used to scatter light. Grids, mesh, and scrims can also be used to scatter the light in differing amounts.

Left—This image by Lenka Perutkova shows the effects of haze in the air. As distance increases the haze lightly scatters the light reflecting from the distant ridges and softens them. With the light 90 degrees to the camera axis the background color shift is slight. The humidity also reflects light, resulting in a decrease in detail, color saturation, and tone as we look through the haze. This produces a slight color shift because the water vapor of the haze absorbs some red light. Since the ridges in the background are brownish, the loss of some red light dulls the color. **Facing page—**In this scene, scattering occured due to the fog and motion of the surf. The light fog diffused the background much more than the foreground. In the midground, the crashing surf created the scattering over the rocks and the soft foamy look of the pool in toward the top right of the image. Photograph by Glenn Rand.

3. Characteristics and Quality

In creating photographs, we are rendering three-dimensional objects as two-dimensional. To create images with impact, we must counter the loss of three-dimensionality with visual excitement. We must learn how to rely upon the character and quality of light to create a sense of depth and add excitement to our images.

In Patrick Stanbro's image there are three light forms—the light scattered by the humidity of the headlights of the cars moving along the Pacific Coast Highway, the stars that form streaks in the sky due to the long exposure, and the reflection of a small amount of light off the bridge.

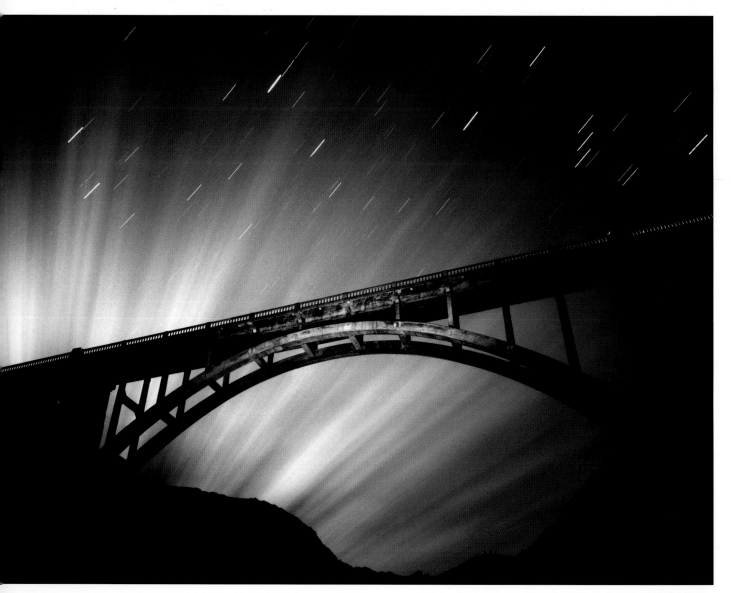

Above—Specular light is created by a light source that is small in comparison to the subject. A point source produces the most specular light, but even a large light positioned far away from the subject can cast specular light. **Right**—The light is direct sunlight. The atmosphere was dry and clear, creating the high contrast that is common with specular light. Photograph by Glenn Rand.

Direct light produces bright highlights and sharp, dark shadows.

QUALITY OF LIGHT

Light itself is not typically visible to us. When we see it, it is usually because we are viewing the source or the light is scattered and/or reflected by small particles in the air (dust, humidity, etc.). In most situations we see the effect of the light in the subject's highlights and shadows and in its effect on the exposure or capture.

There are five primary factors that determine the quality of light. These are (1) its specular or diffuse nature, (2) the intensity of the highlights and shadows, (3) the direction of the light, (4) the color bias of the light, and (5) how well the light fits the capture capabilities of the photographic process. These factors can be seen in all light, whether we create the light quality or find it.

Specular vs. Diffuse Light. Of the five factors that affect the look of light in an image, the most important is the appearance of shadows and highlights. When discussing light, we use the terms *specular* or *diffuse*. Synonyms for those terms frequently make their way into our discussions. The terms *smooth*, *soft*, and *broad* refer to diffuse light, and the terms *hard*, *crisp*, and *harsh* are used to describe specular light.

Specular light is produced when a light source is positioned far from the subject or is small in relation to the subject. This type of light is characterized by a high contrast range. In other words, direct light produces bright highlights and sharp, dark shadows. In the studio, specular light may result when

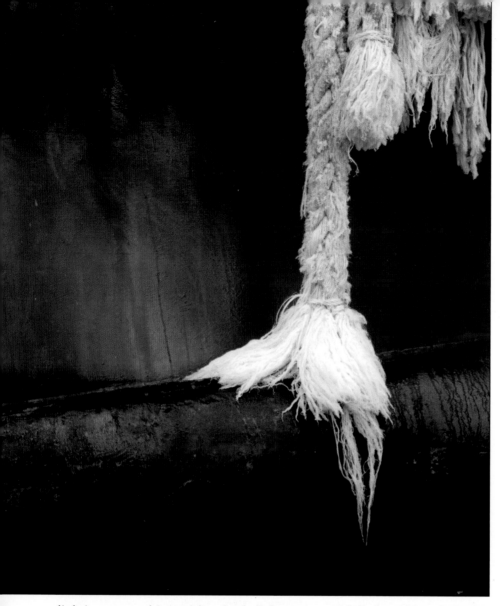

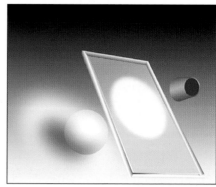

Left—The overcast light allows the detail in the white rope to show while opening up the shadow details. There are no distinct shadows, and the contrast is found in the subject and background. Photograph by Glenn Rand. **Above**—Diffuse light is caused by a source or material that makes the light source large in comparison to the subject. This diffuseness is a factor of size and the distance between the source and the subject.

lighting your subject with a single light source; with little ambient light filling in the shadow areas, there is a high dynamic range. In outdoor work, specular light is produced on a clear day when the sun's light strikes the earth in parallel rays. To envision specular light outdoors, think about the hot spots of reflection the sun creates on a car's chrome bumper.

Specular lighting creates a delineator (i.e., a shadow-transfer edge) that is seen on the subject's surface. This divides illuminated surfaces and those that receive no direct light, thereby defining the shape of the object. When the subjects cast a shadow on another surface, the closer the shadow-catching surface is to the delineator, the sharper the edge of the shadow.

Diffuse light is soft in nature and is characterized by softer shadows (which in some cases may even disappear). In studio work, diffuse light is often achieved by passing light through a large, translucent material placed close to the subject. A softbox is a popular diffuser; however, its proximity to the subject is key in determining the quality of light that will result. Even a softbox can produce harsh light on the subject if it is positioned far away. Soft light may also be created by using a series of lights to illuminate the subject. When

Diffuse light is soft in nature and is characterized by softer shadows.

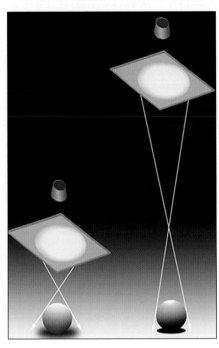

working outdoors, cloud cover, humidity, the direction of the light, altitude, and the particles in the air affect the quality of the light. In the natural landscape, light commonly becomes more diffuse when sunlight reflects off of light-toned surfaces such as snowfields, sand, light-colored rock walls, or even light-colored trees. These surfaces not only reflect light into the shadows but also diffuse the reflected light because they are textured. They often change the color of the light as well.

Light is considered diffuse when it strikes the subject from numerous angles. Diffuse light may come from a large light source. It can also be produced by using a scattering material (e.g., a softbox, diffuser panel, reflector, or umbrella) to break up the parallel beams of specular light. In nature, the hard light of the sun can become diffuse as it passes through atmospheric particles. Because diffuse light strikes the subject from many angles, it can

Left—If the light striking a diffuser is kept at a constant but the diffuser is moved farther from the subject, the light will become more specular. Remember, the more diffuse the light, the softer the shadows and the broader the reflections. **Below—**In this photograph by Chris Litwin, diffuse light was used to produce a high key background. The salad provided the only color and darker tones in the image. Note that the diffuse light opened up the shadows.

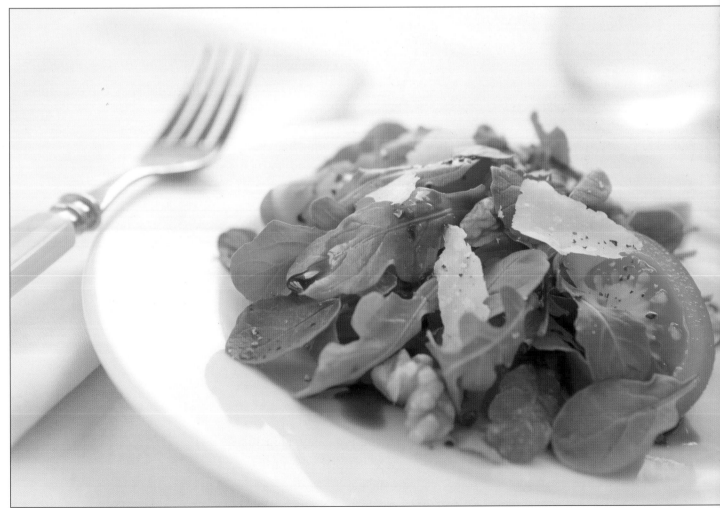

reach around the edges of the subject, filling in shadows and spreading out the highlights. With diffuse light, the highlight will be larger and the falloff to the shadow will be smooth and gradual. The shadows on the subject and the shadow-catching surface will be "open"; that is, they will have light in them and will not have well-defined boundaries.

Direction and intensity being held constant, specular light shows off texture and is more contrasty than diffuse light. Because diffuse light enters the shadows more detail can be seen in the shadow areas with diffuse light. Surfaces will look smoother with diffuse light. Conversely, surface defects will be more apparent when illuminated with specular light. Diffuse light, with its smooth, soft characteristic, is better suited for creating high key lighting. Low key light is more easily created using specular light.

INTENSITY

The intensity of the light in the scene is the primary aspect that establishes the exposure. It also sets the tone of the image. If we break image tone into three basic areas—shadows, midtones, and highlights—we can understand how to make successful images. The richness of an image comes from the shadow areas of the image. With the exception of high key imagery where there is little or no deep shadow tone, the shadow tones are critical in creating the feeling of richness and power in the picture. For the majority of images the middle intensities—the midtones—are the carriers of the information and critical detail. The highlights provide the life and energy to the image.

The lighting intensity at play in the scene impacts the tonal range of the image. There are three main ways that the intensity of light can be modified: (1) by using the power controls on artificial light units, (2) using light modifiers to partially or completely block, change the angle of, or absorb the light falling on the subject or scene, and (3) using the Inverse Square Law.

Artificial Lights. Artificial lights can be turned on and off. Additional units can be added to or subtracted from the light environment. Some lighting units allow the photographer to electronically increase or decrease the light falling on the scene.

Adding light units is a common and often misused way to approach lighting. When lighting many subjects, using the light's off switch may actually be the best way to produce the desired effect. Just because you have a number of lights available doesn't mean they should all be turned on. Use as many light sources as needed, but don't overlight.

Light Modifiers. Disturbing or blocking the light's path can also affect the amount of light falling on the subject or scene. A gobo can be used to completely block the path of the light, and scrims, gels, and grids can be used to decrease the light's intensity. Grids and screens not only reduce the intensity by blocking some of the light; they often make the light slightly more diffuse. Note that when a point source of light such as a focusing spot or bare bulb is fitted with a grid or screen, patterning of the light may result.

UMBRA AND PENUMBRA

The diffuse/specular nature of the light affects shadow creation. A shadow has two areas, the dark shadow, called the *umbra*, and the transitional shadow, called the *penumbra*. With its more focused light angles, specular sources produce less penumbra and crisp shadows. When the light is very diffuse, such as a bright overcast sky, the light angles are so great that there are no crisp shadows created.

The intensity of the light in the scene is the primary aspect that establishes the exposure.

Gels can be added to the front of a light source to reduce its intensity. Neutral density (gray) gels reduce all spectral light coming from the light source. Colored gels change the color of the light and reduce its intensity.

A vignette can be created by using a lower-powered angular light at a relatively close distance or by partial blocking at the light source (e.g., using barn doors), allowing diffraction to create a softened shadow. Alternatively, using edge light from a mostly directional light like a parabolic reflector or soft focused spot can create a vignette.

Once light enters the light envelope it will reflect and be modified by all surfaces it interacts with. Unwanted light can be reduced or removed. This is accomplished by using flags or dark, light-absorbing materials that cut down on light reflecting back at the subject area.

Inverse Square Law. The last of the three ways to modulate the lighting intensity is by using the Inverse Square Law. Simply stated, as the distance between the light and the subject increases, the light intensity decreases (and vice versa).

Brightness and Saturation. Another way that light helps to create a sense of depth, form, and volume is through our perception and interpretation of

Gels can be added to the front of a light source to reduce its intensity.

There are three intensities of light within this image, each resulting from sunlight—the highly noticeable direct sunlight on the right, the diffused reflected light entering the shadow, and the specular reflected light from a window across the street that streaks in from the left. This image illustrates how various intensities can be developed from direct light and specular or diffuse reflections. Photograph by Glenn Rand.

brightness and saturation. Bright objects or elements in the image seem to advance and darker areas appear to retreat. Because color vision requires more light, when we look at a saturated color our perceptual system interprets more light. In this way, saturation functions the same as brightness—saturated colors advance in the scene and duller, less saturated colors appear to retreat.

CONTRAST

Contrast is defined as the overall tonal difference between the darkest and lightest parts of the image. The greater the tonal range, the brighter the highlights will look and the darker the shadows will look. When there is a small tonal difference between the highlights and shadows, the image is consid-

Saturated colors advance in the scene and duller, less saturated colors appear to retreat.

The contrasty specular light aided the double exposure. A single point source light created a horizontal beam, and the subject was photographed in profile and straight on. The use of a point source light made the highlights and shadows crisp. This made the picture elements either maximum exposure or below the threshold of exposure. Since the exposure was below threshold in some areas these would not interfere with the other exposure. Photograph by Glenn Rand.

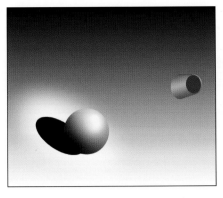 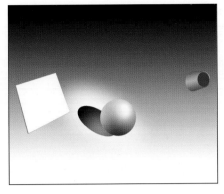 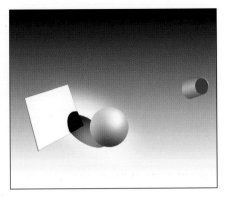

Left—With no fill light, the light ratio is 128:1 (seven stops). **Center**—When a fill light was added, the light ratio was reduced to 16:1 (four stops). **Right**—When the fill reflector was moved closer, the light ratio was reduced to 4:1 (two stops).

ered to be flat. Lighting that creates rich, dark tones and brilliant highlights is said to have a long contrast range. If the lighting provides few tonal separations (e.g., few grays but rich black and brilliant white), it is said to be contrasty.

Lighting Ratios. As mentioned earlier, the overall intensity of the main light establishes the exposure for the image and creates the highlights in the image. A fill light is used to lighten the shadows, making detail visible. The difference between the highlight and shadow values determines the contrast in the image. To describe this difference numerically, a lighting ratio is used. The higher the lighting ratio, the more contrasty the image will be.

A lighting ratio of 16:1 states, for example, that the light forming the highlights is sixteen times more intense than the light filling in the shadows. If the highlights metered f/11 and the shadows metered f/2.8, we'd have a four-stop difference (a 16:1 ratio) between the highlights and shadows. By modifying the intensity of the light in the ways described above, the photographer can manipulate the lighting ratio.

When working outdoors, the sun is the main light. When atmospheric particles bounce light around or the light bounces off of elements of the scene/subject, a portion of the light fills in shadow areas. On a bright sunny day, with a clear sky and low humidity, the light ratio is high—perhaps as high as 128:1. In metering the scene, we would find that there is about a seven-stop difference between the highlight and shadow readings. On cloudy days, the light is more diffuse and the contrast range is lower, resulting in a lower lighting ratio. The same holds true when there are many reflective surfaces in the scene bouncing light into the subject; since more fill light is generated, the lighting ratio is lower. On a very overcast and humid day the lighting ratio can be as low as 8:1 or, in other words, there may be only three stops more intensity in the highlights than the shadow illumination.

Without any fill light, the specular/diffuse nature of the main light will affect the lighting ratio. Specular light produces higher lighting ratios than diffuse light. For example, on a sunny day with no fill the light ratio might exceed 128:1. Under overcast skies, the same scene might have an 8:1 light-

On a very overcast and humid day the lighting ratio can be as low as 8:1.

ing ratio. If a reflector or fill card were used to reflect light into the shadow side of the subject, or a fill light was added, detail in the area would be more visible and the light ratio would be lower.

The introduction of fill light, whether in the studio or in natural light scenes, allows for the reduction of the lighting ratio without the need to adjust the main light. Because some cameras cannot capture the full tonal range of a scene when the contrast/luminance range is high (i.e., very bright to very dark), adding fill can also ensure that the camera can accurately render the scene.

Use of fill lightens dark shadow and allows for the capture of shadow detail. When a reflector is used to introduce fill, there is seldom any change in exposure. When a secondary lighting source is added and fill light spills onto the area of the image illuminated by the main light, the increase in illumination may require a change in exposure. Also, if the power of the fill light or the amount of reflection is close to the effective power of the main light, a crossing shadow may result. There may also be a reduction in texture where both the main and fill light affect the surface.

As mentioned earlier, the non-image-forming light can also enter the camera, decreasing the contrast in the recorded image. When this light comes

Use of fill lightens dark shadow and allows for the capture of shadow detail.

In this image, the light direction is indicated by both the shadows and the light streaks on the wall. The shadows of *The Gates* indicate the sunlight's direction and the relationship of the gates. Photograph by Glenn Rand.

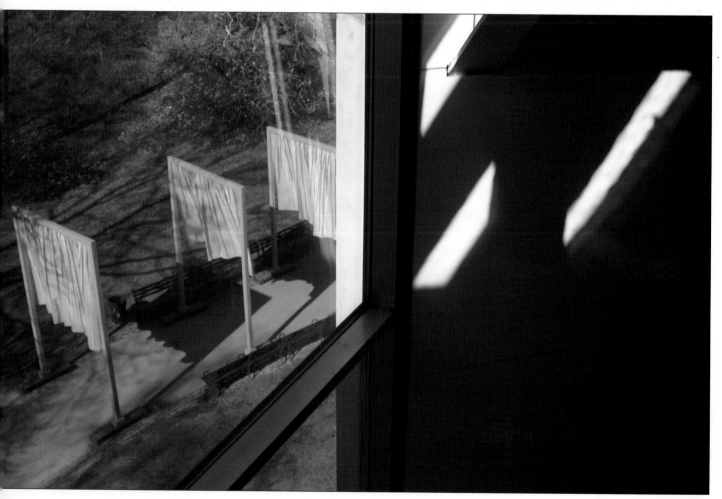

The shadows cast on the post and wall give a strong indication of the depth within the image. Photograph by Glenn Rand.

from a strong point source, polygons of light in the shape of the iris will appear in the print. Diffuse light striking the lens creates a diffuse pattern of light intensity across the image capture surface.

DIRECTION OF THE LIGHT

The direction of the light and the way it interacts with the subject determines the way highlights and shadows will appear in the final image. Interestingly, shadows are a prominent part of many images—and often they are formed by light we are hardly aware of.

Shadows can be dramatic and create great visual interest. The interposition of a shadow falling within the scene creates depth. If a shadow is to be used to create depth, its relationship to the shadow-casting element must be clear to the viewer. If this relationship is unclear, the shadow will flatten the image. Shadow flattening of an image also happens when shadows are very dark. This technique was used extensively by the old Hollywood photographers.

The shadows are defined by the direction of the light in relation to the axis of the camera and/or the shadow-catching surface. The shadow becomes more pronounced and the light seems harder as the axis of the light and the shadow-catching surface become acute. This is because the shadows become elongated and project a more dramatic shape. As the light's axis aligns with

The interposition of a shadow falling within the scene creates depth.

the camera's axis, the light fills in the shadows. This flattens the perceived volume and diminishes texture.

By nature, specular light rays are parallel. Therefore, they show the direction of light better than diffuse light. Because specular light produces higher light ratios, shadows created by specular light will be stronger and more defined than those produced by diffuse light.

The direction of light is of particular importance to architectural and landscape photographers. Landscape photographers are often advised not to shoot at noon, since the angle at which the sun strikes the earth has a great impact on how the photograph will look. Avoiding photographing during certain times of day, and even during certain seasons, allows architectural photographers to utilize a directional light that maximizes shape and detail. To determine when the sun's light angle will be best the photographer can consult a *solar ephemera*, a table of sun angles for any latitude by date.

The distance from the delineator to the shadow-catching surface is critical to the look and form of the shadow. The crispness of the shadow is determined by three factors: the light's direction, type of light (specular or diffuse), and the distance relationship between the source and shadow. This relationship is between the distance from the light source to the shadow-catching surface, compared to the distance from the delineator to the

By nature, specular light rays are parallel. Therefore, they show the direction of light better than diffuse light.

The shadows created at sunrise help define the landforms of the golf course. Photograph by Glenn Rand.

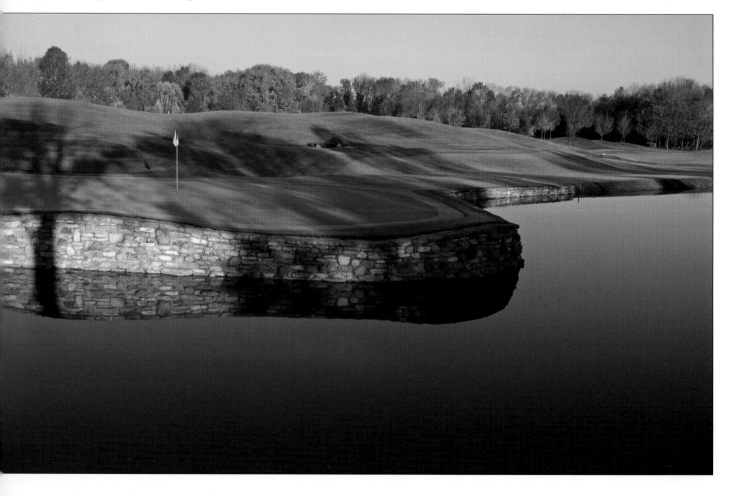

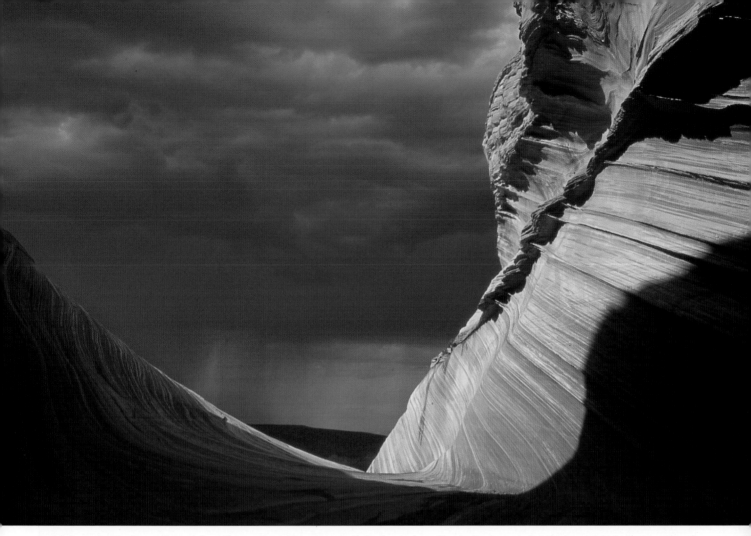

In this image by Tim Meyer, the rock formation on the right is given depth by the shadows. The shadow is created at the lower right by the smooth rock formation on the left. The bowing of the shadow provides an indication of the volume of the rock formation. Shadows in the upper right of the image show the overhangs.

shadow-catching surface. The greater the difference between the two distances, the sharper the shadow. To see this effect, turn on a lamp and look at the shadow of your hand as you move it closer to and farther from the lamp.

If the object casting the shadow stays at a constant distance from the shadow-catching surface, then as the light is moved away the shadow will become better defined. This is true for both diffuse and specular light, though the effect is more prominent with specular sources. Because of the great distance of the sun from the earth and the relative small distances from any object on the earth's surface to the sun, shadows produced on a clear day are distinct.

Because of falloff, a shadow at an object's edge will appear to lighten until it merges into the light.

Because of falloff, a shadow at an object's edge will appear to lighten until it merges into the light. With a spotlight, both the focus and the closeness of attached barn doors create a falloff that many photographers call *feathering*. The amount of feathering is controlled by the way the barn door is positioned and how the focus of the light is adjusted.

The direction and shadow generation also affect our ability to see the volume of the subject in an image. The volume of the subject is easier to see as the light's direction moves to where the delineator can be clearly seen and the

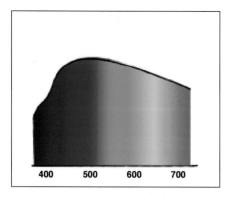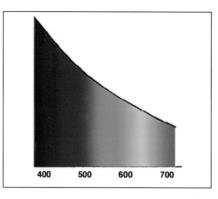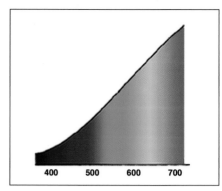

The above graphs show the spectral energy distributions for (left) midday sunny light (clear sky); (center) north light; and (right) tungsten light. The color bias is obvious from the slight cyan of a sunny sky to the highly blue color shift of the north sky and the reddish color shift of the tungsten. Regardless of the color bias of the light, unless heavy in color it will show less in the highlights than in the shading and fill.

light is not perpendicular to the camera axis. This is true for both specular and diffuse light. For this reason, one of the most common lighting patterns has the main light positioned above and at a 45 degree angle to the subject.

As the light's direction moves in relation to the subject/camera relationship the highlights will move, particularly on rounded surfaces. This is very important to the way we see the volume in the subject. Since the dark areas of the image will appear to recede and bright areas will appear to advance, the positioning of a highlight can greatly increase the appearance of shape and volume. The direction of the light establishes where the highlight will appear on the subject. If the highlight appears on a frontal surface, the image will have more volume than if the highlight is on the side or is a rim light.

COLOR

Color has a great impact on images, and its influence extends beyond its intentional use in the picture.

It is important to control the color of the light in capturing images. Though we might see a bright light as white, it likely has some color bias. For instance, light at sunrise or sunset is reddish, and the shade on the north side of a building is bluish. To control the color rendition of the scene, we can use a digital camera's white balance setting, select a film type that matches the light, or employ filters to correct the color bias. At times, the color of the light can add to the mood of the image. When recording an image at sunset, for instance, the reddish color of the light is desirable, and using corrective techniques would negate your efforts.

Though we might see a bright light as white, it likely has some color bias.

As shown in the above illustrations, various types of light sources can produce illumination with unique color biases. Therefore, when more than one type of light illuminates the subject, the colors of the capture vary within the image. The color of the image depends on the light illuminating the highlights and those lights filling in the shadow areas. The most prominent evidence of these shifts are the way light reflects off colors in the scene. We can think of the reflections being filtered by the surfaces so that a light-green

surface, such as a leaf, will look yellow-green under incandescent light but blue-green under north light. This means that the color in an image will vary if part of the scene is lit by window light and another part is lit by a lamp. This can become a difficult problem to contend with for photographers who need to white balance.

An issue that is directly related to mixed lighting is selective reflection. Regardless of the color of the light, colors within and adjacent to the scene will affect the colors in the image. This means that color reflecting into or within the image will be modified by the reflecting surface, affecting the surfaces the reflected light fills. For instance, when photographing a bride outdoors, shadow areas of the gown may take on a green hue. The light reflecting from

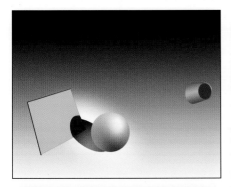

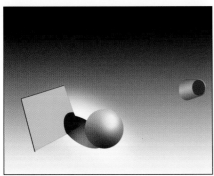

Above—The light reflecting from the green surface shows a green color bias. On a neutral-toned ball the fill will appear green. On the red ball the green does not reflect in its full color from the red. Where the green fill reaches the red ball, it appears less red. **Right**—The pot by Robert Pipenberg was lit with one diffuse light and three fill cards. The fill in the front was white; this added intensity, making the front appear to advance within the image space. Dark-green cards were used to reduce the saturation of the red color on the sides of the pot, causing these to recede in the visual space. Photograph by Glenn Rand.

This image was created using filtration on the lights and camera, along with the effect of complementary lights. A reddish-orange filter was placed on the camera and the flash units were filtered with bluish filters. The light from the flash was complementary to the filtration of the camera. This complementary lighting neutralizes the color of the lighting with the on-camera filter. However, since the light only affects the foreground, the clouds in the background take on the color of the filter on the camera and the trees in the background lose their color. Photograph by Glenn Rand.

a colored material will change color, being affected by both the color of the material and the light's color bias. Where the colors are complementary (red and cyan) the light will be made more neutral. If white light is reflected from a colored material into the subject (as the grass did in the example above), the light will take on a new color bias based on the color of the fill.

Color can play another role in creating images. The color of the light and shadow can become important image elements. The most common way to change the color of the light is to place a gel over the light source. When the main light is colored and there is other ambient light, the shadow of the subject will tend to take on the complementary color of the main light.

SURFACES

The fact that the light reflects from an object alerts us to the importance of the surface quality of our scenic elements when deciding how things need to

The color of the light and shadow can become important image elements.

be lit. Though we can define the light by its quality, we usually do not photograph the light—rather, we photograph its effects on surfaces. Because light is described in terms of its effect on surfaces, we often describe surface qualities as specular or diffuse. A specular surface is shiny and will reflect point source light as a hot spot with very little light being seen on other areas of the surface. Diffuse surfaces spread the light energy over a larger area and create soft, broad highlights with the light decreasing (falling off) across the surface.

Of course, the quality of the light and the quality of the surface that we are photographing jointly affect the overall appearance of the final image.

Specular surfaces allow for richer dark tones and colors since the illuminating energy is concentrated. This may seem counterintuitive, but because the light is concentrated, it doesn't spread into the shadow detail, weakening the depth of tone or desaturating the color. Furthermore, a specular surface does not spread intensity into the light areas and obscure highlight details.

A diffuse surface spreads the light's energy and softens the light's effect. Since the light spreads across the surface, flaws in either the surface or the lighting are downplayed. This is the reason why very diffuse light on powdered faces is used for glamour photography.

Textured surfaces (whether with a regular or random texture) reflect light differently than smooth surfaces. When light falls on a surface with a rough texture, tiny shadows appear on the surface. Finer textures produce less light variation as light is reflected, and the reflection from such a surface is more diffuse than that of a smooth surface. When the textured surface is specular, the light reflected from the surface is more intense than that resulting from

The color of the light and shadow can become important image elements.

When three lights (red, green, and blue) are shown on a neutral ball they mix to create white light. As illustrated here, since the lights are at different angles the shadows and light patterns show both the color of the light on the background and the complementary colors in the shadows. Since the other color lights, except the light shadow, enter the shadow area, the complementary color of the shadow-casting light is evident. In the area where all shadows fall the shadow is neutral. The color fringes of the light pattern on the background are created by the interactions of the three lights where they cross, and the pure color is seen where only one color reaches the background.

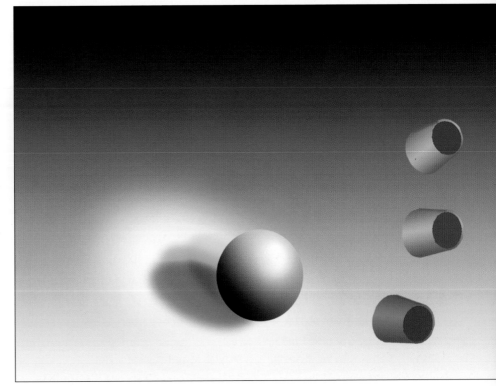

Left—The river ice is a specular surface. The sun's orb is clearly defined even though it was coming through a high thin cloud. The specular surface does not spread the highlight and therefore does not diminish the dark tones or highlight details. Photograph by Glenn Rand. **Right**—The even texture of the sand creates diffuse surfaces that spread the direct sunlight. Though the contour of the dunes provide some shadowing, the diffuse surface softens the light's look. Photograph by Glenn Rand.

a matte textured surface. If the texture is regular and specular (i.e., more mirrorlike), the reflections will be more concentrated.

When light strikes a smooth surface it penetrates the material slightly before reflecting the small diffuseness, producing an inner reflection and giving a pearly look. If the light penetrates the surface and is diffracted as it is reflected, the returning light produces an opalescent effect, creating colors in the reflection.

Moisture on a surface further changes the way light is reflected. When liquid thinly covers the entire surface it creates a mirrorlike effect and we see more reflection in the darker tones and colors. Though a wet white surface reflects light, details in the reflections are more apparent on darker surfaces. Both the camera and our eyes are better equipped to see light energy when light is reflected from a dark surface. (*Note:* Deeper water is a specular surface and will be discussed in chapter 6.)

When a thin film of water or other clear liquid covers a surface, it will be specular no matter the original surface type. For example, dry skin is diffuse,

Moisture on a surface further changes the way light is reflected.

but with a moisturizer applied the skin becomes slightly specular. If oil is applied to the skin it becomes more specular. The liquid also smooths the surface by filling in the low spots and removing texture or other low-profile "flaws" such as blemishes or scratches. Unless it is heavy, sweat will usually cause small beads of specular reflection.

In terms of the range of light that can be seen in a reflected intensity on a surface, specular surfaces reflect a higher dynamic range than diffuse surfaces. For this reason, newer techniques that utilize ray-traced images on specular surfaces (such as a computer-designed but not-yet-built car) require the use of high dynamic range imaging (HDRI) so that virtual reflections can be shown on shiny surfaces.

There is a thin layer of water covering the entire surface of the subject, making it specular. The sky was totally overcast, creating the soft reflections on all parts of the scene. Photograph by David Ruderman.

FIT

The exposure latitude of the film or image sensor will have a major effect on the outcome of the final image. Ensuring that your film or digital camera can record the full range of light intensities in the scene determines, to a great extent, the success of the capture. However, this is only part of the equation.

In a well-exposed image, we should have tones that range from the low end to the high end of the film/digital image sensor's tonal sensitivity range. This suitability of the capture media to the light environment is termed "fit."

Understanding fit is easiest in the digital environment. In 24-bit color (8 bits per channel) the histogram shows the distribution of tones in the image, from black (0) to white (255). If there are a great number of pixels in the image at any one level, the data will be high at that point on the graph. When all the intensities are plotted at the left edge of the histogram, the image is underexposed. When all of the intensities are plotted at the right edge, the image is overexposed.

When data is spread from one end of the histogram to the other, there is a full tonal range in the image. However, tonal values from about 0–11 and 243–255 will not show detail. Therefore, setting the black point to 12 and the white point to 242 will ensure an excellent tonal range that suits the output capabilities of today's inkjet printers.

When working with film, densitometric measurements are required to determine the thresholds for useable exposure. The term *Dmin* is used to refer to the minimum usable dark tone. *Dmax* refers to the maximum useable highlight density for negatives. The terms are reversed for transparency film. The difference between the minimum and maximum captured light values is known as the dynamic range.

The Zone System can be used to ensure that the quality of light in the subject/scene is represented in the final image. The system adjusts the development of film to the quality and tonal range of the light. For more information on the Zone System, see my book, *Film & Digital Techniques for Zone System Photography*, from Amherst Media.

In analyzing this histogram we can see a spike in the data at the right (white) edge; these values pertain to the reflection of the sun on the rounded surface. There are a few tonal values at the other end of the histogram, close to the threshold for black. All the other tones fit the capture capability of the CCD.

If the capture dynamic range cannot accommodate the tonal variation in the scene, the lightest captured tone will be reproduced as white and the darkest tone will be reproduced as black. In this situation the subtleties of the light will be lost and the image will be contrastier. When the tones in the scene do not span the full dynamic range of the capture medium, prints will appear muddy.

The following examples are given as a guide for achieving fit with various capture media. Transparency film, the media with the smallest capture range, can capture a light variation of about six stops (e.g., heavy overcast or light rain. In bright sunlight the shadows will go to black and the highlights will shift to white if exposing for midtones such as skin tone). Color negative film is sensitive to a great dynamic range (perhaps sixteen stops or more), but when traditional color printing materials are used without special handling, the dynamic range is reduced to about eight stops. When negative film will be scanned, the capture dynamic range will determine what you can produce from the negative. Without special handling, overcast conditions present the best natural lighting for maximizing color negative film images. Black & white film can capture an eighteen-stop tonal range. Without specialized processing and printing, however, a standard black & white print will act as though it has a dynamic range of about ten stops as determined by the paper. The ten-stop range relates well to a hazy bright sky. Finally, digital sensors will capture a dynamic range in excess of twelve stops (e.g., a bright, sunny day in non-desert locations). Some specialized high dynamic range imaging (HDRI) cameras can capture up to twenty-six stops, making it possible to accurately capture images in a darkened building or bright sunlight.

Digital sensors will capture a dynamic range in excess of twelve stops.

4. Control

A CONCEPT FOR CONTROL

Light is light. With few exceptions, whatever you can do with one light source can be done with another. The same physical realities that affect a short burst of an electronic flash impact continuous light from the sun. The laws of physics control the actions of light and make light controllable. When you understand the limits of what can be done physically, you can creatively enrich the visual aspects of your image.

With few exceptions, whatever you can do with one light source can be done with another.

The overall effect of the light in the scene is determined in part by what will be included in the image. Here the set includes a glass dish and bowl, the translucent soup base, shiny metal silverware, and a variety of diffuse surfaces in the cloth and foods. Photograph by Glenn Rand.

Three light sources were used to create this image: the main light was a large softbox above the subject; a spotlight was used on a white board behind the set to create the broad reflection on the Plexiglas, tomatoes, and olive; and a small spotlight was used to create a specular highlight on the olive and open up details under the bun. Fill cards were placed directly in front of the set, and a large white fill was placed behind. A low black board was positioned directly behind the subject providing the dark background while allowing the large white fill to produce reflections in the image. The totality of the lights and modifiers and their effects makes up the light envelope. Photograph by Glenn Rand.

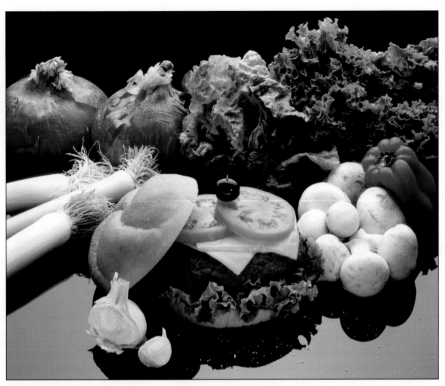

The totality of the light around an object makes up the "light envelope."

In looking at lighting as a problem-solving approach we need to establish the limits of our control. But what are these controls? Primarily we control the intensity, how light is reflected, how we modulate the light, and how we will scatter the light. Refraction plays a lesser role in lighting other than in lighting equipment and some subject interactions. Absorption affects the appearance of a subject's color, which in turn impacts the color of the light. Dispersion affects photography mostly within lenses though also in lighting glass. Polarization has its greatest impact in reducing unwanted reflections, including light reflecting around the atmosphere. Diffraction is the least effective of our lighting controls.

To produce the very best images, we can: (1) change the intensity of the light, (2) reflect the light, (3) scatter the light, (4) modulate the color of the light, and (5) control the way shadows are formed. This is a small number of controls; however, the controls work, and with a limited number of considerations at our disposal, we can focus our mental energies on our creativity.

THE LIGHT ENVELOPE
When conceptualizing our images, we must consider not only the light that is directly shining on an object we will photograph but also how other areas of the environment will affect the look of the image. The totality of the light around an object—the main light, any fill lights, all reflections, and the ambient light around the scene, plus the qualities of those lights—makes up the "light envelope."

Often photographers consider only the impact of the main light and any controlled fills on the subject or scene they are photographing. In a totally

black studio this concept has some validity. However, in most cases, the various surfaces of elements in the scene and the way light affects them must be considered. Also, light is affected *by* the surfaces it encounters. This too impacts the overall image. The importance of these interactions depends largely on the characteristics of the scene. When photographing metal and glass, for instance, the light envelope impacts the subject/scene more than the main light.

It is easy to think of a light tent as a light envelope, as it becomes clear that the totality of light in the environment is affecting the object being photographed. We must realize, though, that this same premise holds true when working in "found" lighting environments as well. For example, when photographing a group of people on a sunny day in the desert, we will consider the effect of the light from the sun. However, we must realize that this light will also reflect from the light-colored sand and the T-shirts the subjects are wearing, filling in the shadows. If an on-camera flash is used to fill the shadows, its light is also part of the light envelope.

INTENSITY CONTROLS

Digital sensors are unforgiving when it comes to overexposure. When a sensor receives its maximum light intensity at any pixel it may "bloom" and spread that energy to neighboring pixels. This will create bright areas that extend beyond the original captured area. When this happens, there is no ad-

Only one light source was used to create this image, but its effect throughout the light envelope was varied. The sun had not yet fully arisen so the light spread across the sky. Because the light intensity varied across the sky, light reflected and silhouetted the trees on the surface of the water. The light from the top of the sky illuminated the bottom of the swimming pool. Photograph by Glenn Rand.

ditional image data in these areas, just white. Transparency film is similarly intolerant of overexposure but is less forgiving of underexposure. Negative films are more accepting of overexposure than image sensors or transparency films, but the medium has its limits.

As mentioned before, the control of intensity happens positively and negatively. Intensity can be added and subtracted for both the light sources and the light in the envelope. The easiest way to add or subtract intensity is to use the light's on/off switch.

When carefully controlled, additional lights can be employed to increase intensity generally or specifically. This is even the case when photographing in natural light. John Sexton tells a story about the making of his image *White Boulder, Dead Horse Point, Utah,* which was exposed in the subtle available ambient light after sunset. He envisioned the white boulder in the foreground as being a lighter tone, to separate it from the background. In this situation, he took an approach that was a departure from his usual way of working. To quote John, "I photograph with available light, and I had a flash unit available so this specific time I used it." It was important to create more intensity in the foreground, and adding light by multiple flashes allowed John to accomplish this. He used multiple flashes from many positions to create a diffuse light similar to the quality of light in the rest of the scene.

Intensity can be added and adjusted in a variety of ways. As previously mentioned, a light source can be added to illuminate all or part of the light envelope. Depending on the subject, careful control over this additional light may be important. Keep in mind that adding extra lights may adversely impact the existing setup, particularly when photographing highly reflective surfaces and transparent materials.

Many light units feature built-in intensity controls. Many units rely on rheostats to adjust the amount of current powering a continuous filament. Variable capacitors or shunting circuits are commonly used to control the light output by electronic flash units. Note that using an incandescent light or flash tube will change the intensity of the light but will also affect the color of the light in the scene. There are also pieces of equipment that use multiple filaments in a single bulb, or multiple bulbs. The great portrait photographer Yousuf Karsh used a simple method based on light intensity to accomplish his photographs. If he wanted a 3:5 light ratio, he would use five bulbs as the main light and three bulbs on the fill side. All the bulbs were the same wattage and were mounted in arrays next to each other. Both arrays were positioned the same distance from the subject.

The intensity of the light can also be increased or decreased by adjusting the position of the lights. The Inverse Square Law states that moving lights closer or farther from the subject's surface changes the intensity of the light. Shutter speeds, f-stops, ISOs, and the Inverse Square Law are all based on a mathematical square function and therefore work well together. When the light's distance from the subject is doubled, its intensity will be reduced to $\frac{1}{4}$.

Because of the square relationship, when doubling the distance of the light from the subject you lose two stops. If you halve the distance, you gain two stops, producing four times the intensity.

The relationship outlined above provides us with a starting point for gauging the effects of light on the scene, but the exactness of the approach depends on the characteristics of the light. Most people use the following formula to illustrate the Inverse Square Law:

$$E = I/\Delta d^2$$

In this formula, E is the energy at the new distance, I is the intensity at the original distance, and Δd is the change in distance (or the new distance divided by the original distance). The final step in the formula is to multiply Δd by itself (i.e., squaring the number). The correct way to write this formula, however, is:

$$E = I \cos\Theta/\Delta d^2$$

In this formula E, I, and d^2 are the same as above. The difference between the two formulas is the $\cos\Theta$ in the second formula is multiplied times the intensity of the intensity. $\Cos\Theta$ refers to the angular spread of the light source. This has to do with the structure of the beam of light. A point source of light will have a $\cos\Theta = 1$ along its beam. With a diffused light the value of $\cos\Theta$ is less than one, and thus the new intensity is not simply the inverse square for the ratio of the distances squared for most light sources. However, for our purposes, it explains how intensity changes with the change in distance.

When doubling the distance of the light from the subject you lose two stops.

According to the Inverse Square Law, when two identical spotlights are placed in front of a board, one at a distance of four feet (left) and another at a distance of two feet (right), the intensity of the spotlight placed two feet from the board will be four times brighter (two stops more light) than the spotlight positioned at four feet. In other words, if the reading on a light meter in the left light pattern is f/4, the reading in the light pattern on the right will be f/8.

Intensity in the image is quite clear. The four lights mounted on the oil tank are seen as incident point sources. We can see their reflections, the falloff, and the creation of shadows. Because the lights are small enough to act as point sources the streaking of the reflections and shadows are visible. Photograph by Glenn Rand.

A small diffuse light added to a specular light pattern will soften the highlights.

Reflected intensity does not vary with a change in the distance of the lit subject from the camera; only varying the distance between the light source and the subject affects intensity. This can be easily seen when photographing a landscape in a desert with a clear sky. The exposure for the distant horizon, the middle ground, and the foreground are all the same and not determined by the distance from the camera.

The specular/diffuse characteristic of the light affects the Inverse Square Law but does not determine the intensity of the light. Though the power of a lighting unit will be diminished if it is put through a diffuser screen, once the light is defined as to its type (specular/diffuse), the major factor affecting the light's power will be its distance from the subject.

The addition of small amounts of specifically added light is valuable in accenting detail and drawing attention to specific areas of the image. Small specular sources can produce specular highlights that visually enhance a textured surface's variations. A small diffuse light added to a specular light pattern will soften the highlights.

Painting can also be done with fill light. This image was done as a very long exposure with the fill moved in relation to the shell during the exposure. In this way the amount of fill was changed for varying parts of the subject. Photograph by Glenn Rand.

Light can also be strategically used to draw attention to an object's edges. A diffused light illuminating one side of the transition separates the surfaces, while specular light aimed directly at the transition edge creates a specular highlight streaked along the edge. If the surface is diffuse, a fine specular accent streaking the edge will give an appearance of more pronounced edge detail.

"Additional lights" does not necessarily mean extra lights. With still life or architectural photography lights can be turned on or off as needed. With electronic flash, multiple "pops" can be used. During a long exposure, the flash unit can be aimed at the foreground subject and fired multiple times from different positions. This technique is common enough that several manufacturers offer meters that calculate light produced this way. Knowing the true effect of your flash (i.e., the relationship between the guide number and number of pops) allows for exact tuning of this additional light.

With long exposures, a hooded flashlight or HoseMaster can be used to "paint with light" and selectively add light to specific areas of the scene. It is

Light can also be strategically used to draw attention to an object's edges.

important that the additional light be aimed away from the camera and that you or any object not desired in the picture not cast a shadow or block the lit subject during the exposure.

Whatever the method, using longer exposures when adding light affords a greater degree of control. If an exposure is four seconds, a one-second error can be equal to ½ stop. For a sixteen-second exposure, a one-second error will go unnoticed. Eight pops will yield a smoother effect than making an exposure with just two pops, even if the calculated exposure is the same.

Depending on the choices made for the number of pops, length of painting, or distance the additional source is from the subject, effects can range from delicate to extreme. The direction of the additional lighting will also affect the look of the image. If the pops or painting all come from the same direction, the additional intensity will have the characteristic of the additional source. If the direction of the flash unit or painting tool is changed continually, the light will be more diffuse.

For film based photography, long and multiple exposures may not expose the same as normal single exposures. The caveat for this method of adding multiple exposures with light is that with some films there may be a reduction in effectiveness of the emulsion to react to the repeated exposures. This is known as *intermittency effect* for multiple exposures and *reciprocity failure* for long exposures.

With digital imaging the concept of layering different lighting effects allows for exact control of specialized light intensities. While lighting effects can be layered to arrive at a desired look for the image, the lighting must be correct for each part.

One of the most common ways that additional light is placed into the envelope is by use of reflection. This is usually done to reduce the contrastiness of a subject by opening up the shadows. When a mirror is used as a reflector, the light coming from the surface of the mirror will be of the same type as the source that it is reflecting. For example, if you are reflecting a spotlight, the mirror takes on the form of a spotlight the size of the mirror. If you are reflecting light from a diffuser panel, the light reflected from the mirror will be a diffuse source the size of the mirror. If additional light is needed only on the label of a bottle, a mirror can be positioned to reflect a small amount of light only on the label. If the shape of the mirror does not match the desired beam of additional light, the mirror can be partially covered to create an additional light for the label. This modification can be done with any material, tape, paper, paint, etc.

It is easy to think of adding light, but reducing light is often as important in establishing the correct light envelope for a photograph. The switch that turns on a light also turns it off.

There may be a need to reduce the intensity at a certain area within the light envelope or over the entire scene. Alternatively, there may be a need to keep light from affecting the scene. The most obvious solution to these prob-

Using longer exposures when adding light affords a greater degree of control.

In order to have enough light on the dolls' faces, small mirrors were used, each with a cookie (also known as a cookaloris) attached to limit the size and shape of the reflection so that it added illumination to just the desired area. Photograph by Glenn Rand.

lems is to use a blocking device. The most common of these are gobos and barn doors.

The term *gobo* comes from "go between." Gobos are opaque materials that are placed in the light's path. The size, shape, and color of a gobo are dependent on the need of the light envelope. Boards or cards are commonly used and supported or suspended in the light's path.

A small gobo is often used to block light from the camera's lens, thereby reducing flare. Frequently the gobos are black on the surface facing into the light envelope so that they do not become reflectors and reduce the amount of light reflections within the light envelope.

Large gobos are used to block light and reduce exposure problems. They are often used to surround or separate the light environment to keep ambient light from intruding on the envelope. Particularly with higher intensity backgrounds, a common problem with lit backgrounds is flare. To prevent flare, gobos are placed on the sides of the setting, beyond the image's edge, with the black surface facing the camera.

Barn doors are also used to block and direct light. They are constructed as single blades, opposite sided, and four-sided arrangements that attach to the front of a light and can be rotated about the axis of the light. This gives more control over the way the blocking is seen in the light envelope. Ordinary barn doors are a black lightweight metal plane attached to the front of the light with a hinge. The hinge allows for the barn door to be moved into the light's path blocking a portion of the light. Occasionally they are made of several movable parts that allow the barn door's shape to be modified.

Four-bladed barn doors are mounted on the light source with the ability to rotate. This provides the opportunity for positioning of shadows and feathering. Furthermore, these barn doors have hinged wings that allow for the size and shape of each blade to be modified for maximum control. Courtesy of Lowel-Light Manufacturing, Inc.

Left—Because of the coloration of the vase, a gradated background was selected. This allowed accenting the top against black while defining the lower portion against the middle gray. Vase by Michael Rand. Photograph by Glenn Rand. **Right**—Using a large black gobo placed above the diffuser created the gradient. Since the shadow of the gobo feathers on the rising area of the seamless backdrop and it is a diffused light, the shadow gradually darkens. With the large gobo placed above the diffuser no light falls on the back of the seamless backdrop and that exposes as black.

Above—Color screens act like gels. They change the color of the light to match the color balance of the film or a digital white balance setting. By gelling a light, you can also make its color temperature match that of a different source. Courtesy of Chimera. **Right**—This detail of a film set shows how controlling the light intensity on the rear surface creates the impression of a much larger space. Photograph by Glenn Rand.

Because the barn door is attached to the light source the light blocking generates a shadow and a feathered edge. The structure of the light pattern produces a fully lit area, the feather (where the light is losing its intensity), and the shadow cast by the barn door. Usually the light's position can be adjusted allowing the control of where the light, feather, and shadow will fall.

Feathered lights can be added to cover a larger area without a noticeable change in intensity. Because a barn door's edge creates falloff (i.e., feathering), the farther the light source and barn door are from the shadow-catching surface, the softer and larger the feathering will be. Overlapping the

feathered portions of the light from each source creates the larger pattern of directional light.

Being so close to the light source, particularly with continuous lights, the barn door will heat up as it absorbs the heat energy striking it. For this reason it is safer to use tools or gloves when adjusting the barn doors once the lights are on.

For a uniform decrease in light intensity, gels can be used. Gels gain their name from the gelatin that camera based filters were originally made from. The material used to make gels is clear and can be toned or colored or impregnated with materials that change the light passing through them. When gels are just toned, they are neutral density and only vary the intensity of the light. Color gels decrease intensity and also change the color of the light. Some gels can resist the heat of the light source.

Color gels decrease intensity and also change the color of the light.

Screens and grids can also be used to decrease the intensity of the light, though they are commonly used to scatter it. Depending on the light source used, though, they can cast a light pattern in the light envelope. The more specular the light source, the more likely this will occur. This is particularly the case when the screen or grid is placed close to a focused or collimated light source.

Sometimes the light within the envelope has reflections that are not helpful to the image. A flag can be used to control unwanted light in the envelope. Flags are black, heavily textured material that cuts down on reflections. Flags are particularly helpful in lighting shiny and transparent subjects and to increase contrast. Tuning the light with a flag means increasing or decreasing the flag's angular affect; this is done by moving it closer to and farther from the subject. When the flag is close to a shadow area, the lighting ratio will be higher for that area in the envelope.

A flag can even make the light seem directional. When a flag is used in a very diffuse light envelope, it restricts light from reaching the fill areas and provides a feel that the light is coming from the side away from the flag.

With some subjects, more light sources, each with its own control, may be required. Unfortunately, this can build up unwanted intensity. Particularly with digital capture and transparency film too much light can be problematic. Though we may need to use more or different light interactions to achieve the lighting for the subject, intensity control will be critical.

REFLECTION CONTROLS

Reflection is a major tool for adding intensity and controlling contrast within the light envelope. Normally every subject we see has a reflective quality. The reflectivity of parts of the subject or set will affect the lighting within the light envelope. For this reason even landscape photographers often deal with how light is reflected about scenes as they contemplate the timing of exposure.

Every reflection acts as a light within the envelope, though usually only powerful or planned reflections get our attention. All controls that affect a

This lighting setup was used on a movie set. A light is shown onto a white card reflecting light back into the set. Photograph by Glenn Rand.

Reflection is not always used to move the light to be seen; sometimes it is used to reflect the light away or to build the image. This image, created for a magazine cover, was intended to convey the change from conventional 35mm film cameras to emerging digital cameras. The photograph was a double exposure with the reflection off black Plexiglas. The black Plexiglas would reflect only the highlights. Because the light was above and slightly in front of the cameras, the light that reflected from the cameras was seen but the light that hit the Plexiglas would reflect into empty space and not be captured. A black pattern behind the cameras and its reflection concealed the double exposure effect. Photograph by Glenn Rand.

light source can affect reflective surfaces. Reflected light interacts the same as any other light. Also reflecting the light changes shadow production.

In chapter 2, we covered a basic tenet of lighting: the angle of incidence equals the angle of reflection. This simple light interaction allows us to use reflections successfully as we make images whether we are using ambient light or studio lighting.

Angular control can be adjusted in two ways. The reflective surface can be moved to change the reflected light's path, or the light can be moved to affect the reflection. It is easier to make small adjustments in the angle of the reflection by moving the light. This may not be an option if the main light is being reflected or if the light is not in your control, such as fixed lights or the sun. In this case, the reflecting surface can be rotated.

Beyond the angular consideration of reflection that allows us to take control are surface characteristics, shape, and color. Most obvious is the impact that various surfaces will have on the reflection. Just as surfaces can have various amounts of diffuseness, so will their reflections. Assuming a specular light, the more diffuse the reflecting surface, the more diffuse the reflection. While this is true for specular light, for diffuse light all reflections from all surfaces will be diffuse. With a small mirror diffuse light will still reflect as diffuse light, but the pattern will be small and, placed at a distance from the subject, the light can take on some specular characteristics.

Perhaps the most commonly used light modifier is the reflector. This is often nothing more than a white card. Mirrors, textured metallic reflectors, and colored materials are also used. Some lighting equipment such as umbrellas, parabolic reflectors, and nimbus screens are designed with reflection of light as their primary function.

As with any other light source, a fill reflector will create light effects depending on the distance, reflective surface, or light quality. Shadows can be problematic with reflective fills. Many times a fill placed too close to the subject will create highlights and shadows that appear contradictory to the light direction of the main light.

Both the contour and the distortion of the surface affect the reflected light. As seen with mirrors reflecting specular or collimated light, the contour shape of the reflecting surface controls the shape of the beam of light coming from the mirror. The shape of the reflecting surface can be its physical contour where the surface is cut or broken to a shape or it can be masked or painted on with black matte paint to reduce the reflections from parts of the surface. A painted mirror can serve the same purpose as a cookie, casting a patterned shadow or, more accurately, patterned light onto the subject or scene. (For more information on cookies, see page 113.)

When the reflecting surface is distorted, the reflections are also modified. Particularly noticeable are reflections from mirror surfaces. Concave surfaces, such as a makeup mirror, will bring the light into focus. When direct sunlight is reflected off of such a surface, heat energy intense enough for cooking can

This image shows three effects of scattering. First, the scattering caused by humidity and particulate matter in the air means that, as the distance between scenic elements and the lens increases, density decreases. This is due to scattering caused by humidity and particulate matter in the air. Second, because the photograph was taken toward the direction of the rising sun, the effect is more pronounced. Last, the humidity not only scatters the light but absorbs the red spectral portions of the light, creating the varying blue densities. If the scatter was caused by dust in the air, the mountains in the background would have receded as tones of brown or tan. Photograph by Glenn Rand.

result. Simple bending of a mirrored surface to make it concave on one axis can make the reflective light form a line.

When a surface is convex, the light source will concentrate on the reflector's surface. When the surface is specular, like a round Christmas tree ornament, the light is seen as a spot but reflects in all directions. The light reflecting is not diffused by a specular surface and acts more as a point source.

SCATTER CONTROLS

We do not think of controlling the light when we work in nature; rather, we react to what is presented to us. However, the way natural light is scattered gives us control in our photography.

In nature, light is either scattered by climactic conditions or is reflected and scattered when it hits our subjects. Atmospheric conditions scatter the light that shines on our subjects. A humid atmosphere (a hazy sky) will scatter the light slightly—particularly in the blue and ultraviolet areas of the spectrum—and open up the shadows slightly, decreasing contrast. Because the light that is scattered is at the short end of the spectrum, a haze filter or UV filter can be used to increase the shadow depth and make the sky appear darker. But the filtration will not eliminate all effects of the haze breaking up the light coming toward the camera. Because of the sensitivity differences between sensors and film, these effects will be more pronounced with film.

High thin clouds affect the scene differently, though at first glance the effect appears similar to haze-induced scattering. High thin clouds create a

When a surface is convex, the light source will concentrate on the reflector's surface.

slight diffusion of the light similar to scattering created by a large diffuser. Because the shadows are opened by a slight diffusion, filtration for short wavelength light is not as effective as it is when the light is scattered by other atmospheric conditions. A completely overcast sky creates more diffuse light. Depending on the thickness of the cloud layer the diffuseness as well as the brightness will be affected.

When humidity levels are high enough, fog forms. The fog diffuses the light, of course, but it is possible that the light will also reflect off the humidity within the fog, producing further diffusion. Upon reflecting off of the subject, light is scattered as it comes toward the camera. This scattering is more noticeable with bright parts of the subject creating halos and softening bright contours.

Shadow detail and dark areas are lightened when light scatters into these areas. With fog or haze the effects of scattering are more noticeable when light comes toward the camera, whether from the illuminating source(s) or reflected from the subject. To lessen the effect of haze, photographing with the sun behind the camera is best (this is more effective for haze than fog). When fog is very dense there will be little direction of the light; as it thins, the directional light will become more apparent.

In controlled lighting situations, the scattering occurs between the light and the light envelope, between the light envelope and the camera, or both. A scattering material is generally placed between the light and the envelope. Diffuser panels, scrims, and screens are used to scatter the light before it

Shadow detail and dark areas are lightened when light scatters into these areas.

The fog breaks up the light as it falls on the subjects and as it reflects toward the camera. Because the light is scattered before illuminating the subjects, the shadows are very open. Photograph by Glenn Rand.

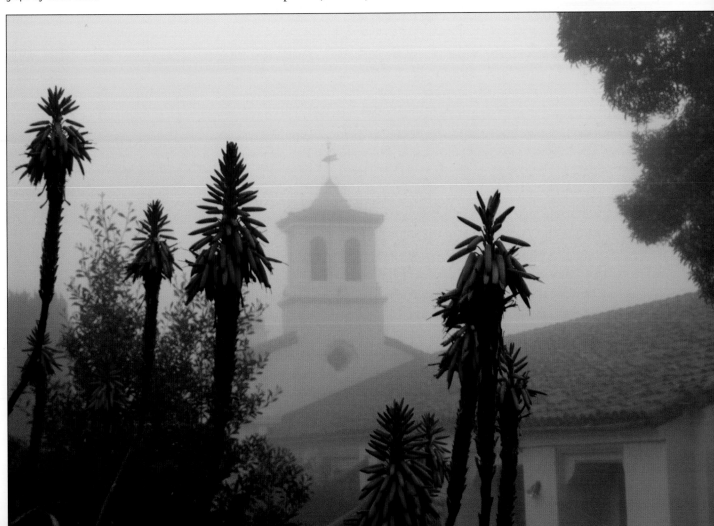

This apple was photographed on a Plexiglas light table that diffused the light from below and behind, producing the even white ground as well as the light reflection below. Photograph by Chris Litwin.

reaches the subject. Softboxes use a diffuser, or sets of diffusers, within a construction that allows the light to exit the softbox only through the diffuser.

The amount of scatter is related to the density of the scattering material and the direction of the light striking the diffusing material. For example, gauze will not scatter the light as much as densely woven cotton. Frosted Mylar will not scatter as much light as white Plexiglas. With less material in the way to scatter the light, the illumination will be more specular.

In the studio, if the light is aimed at the subject through a less dense diffuser, such as frosted Mylar or light cotton, the light on the subject will look similar to haze with open but distinct shadows. Having the light strike the diffusing screen indirectly or at an angle so that it is not aimed at the subject will produce highly diffuse light. For this reason, diffusing equipment is often designed with the light source shining away from the diffuser screen. Specifically designed equipment, such as the Broncolor Hazylight, shines the light off a parabolic reflector from the focus of the parabola to form parallel light rays before being diffused by a translucent panel. When using a diffuser screen if the light is shown across the material the light becomes more diffuse.

With less material in the way to scatter the light, the light will be more specular.

The light coming from the subject can also be diffused. A variety of filters can be attached to the lens to scatter all the incoming light (e.g., a soft-focus filter) or portions of the light (e.g., a fog filter). The denser the filter, the greater the scatter. When a filter scatters the light coming from the subject, the brighter the reflection, the more the scatter. Motion of material in front of the lens (e.g., a mechanical filter that spins in front of the lens or manually moving gauze) will also scatter the light entering the camera.

Some filters are designed to scatter the light in specific directions. These contain a regular linear pattern that scatters or diffracts the light. The light will scatter from bright light areas of the subject in the direction of the lines. When the lines are in a crossing pattern a star is formed. Though the star is created, the scattering also affects other areas, softening the image. If the linear pattern is very fine, a diffraction grating may be created. The diffraction from the lines will create a spectrum spreading from the bright spots within the image.

SHADOW CONTROLS

Though light creates exposure, most people pay a great deal of attention to the shadows in an image. To ensure the shadows add impact in the image, three controls can be used. These are the direction of the light, the diffuse/specular nature of the light, and the ratio of the light source's distance to the subject compared to subject's distance to the shadow-catching surface.

Direction. Landscape photographers often wait to take photographs until the sun's position in the sky allows for a direction of light that will produce the desired shadow. When working in a controlled situation, the light can be positioned to cast the shadow in a desired direction. Usually moving the light produces better results than repositioning the subject to create the desired shadows.

This image was made with a spotlight aimed at the subject through a diffuser. This produced a diffuse source with a specular portion. The specular portion creates the drop shadows, and the diffuse nature of the light opens the shadows and reduces the shadow density, allowing the fit required for printing. Photograph by Glenn Rand.

Specular/Diffuse Light. The crispness of the shadow is dependent upon the specular/diffuse nature of the light. As discussed earlier, the more specular the light, the crisper the shadow. If crisp shadows are desired, a spotlight or flood lamp with a small bulb can be used to produce the desired look.

The shadow developed from this lighting pattern shows the feathering created by the difference in distance of the light, ball, and the shadow-catching surface. As the difference increases toward the bottom of the shadow, the feathering grows in size.

The degree of sharpness of the shadows vary depending on the distance of the shadow-casting object from the side of the boat. Where the rope is close, its shadow is crisp. The shadows from more distant objects are softer. Photograph by Glenn Rand.

Crisp shadows can also be produced with a diffuse light source, so long as a specular light is embedded in the diffuse light or used to supplement the diffuse light. The diffuse light will open up the shadows, allowing a better perception of the shape of the object. Another way to ensure crisper shadows with a diffuse light source is to aim a spotlight at the subject with a diffusing panel placed in front of the source.

Distance. The third factor that determines the look of a shadow is the distance between the light and the object casting the shadow compared to the distance from the object to the shadow-catching surface. When this ratio is very high (e.g., the distance of the sun to the earth compared to the height of a man standing on the ground), shadows are crisper. If the light distance stays at a constant and the shadow-casting object is moved farther from the shadow-catching surface, the shadow will become softer. This is true when the light is diffuse.

Diffuse light will open up the shadows, allowing a better perception of the shape of the object.

As the distance increases the light source becomes less angular. Because the light becomes more like a point source light, the shadow characteristic becomes crisper. For most light sources the light produces less of a feathered edge as the light wraps around the object. Even the sun, as far away as it is, produces feathering. When looking down from an airplane the shadow will be crisper on a cloud near the altitude of the plane than on the ground thousands of feet below. Because the shadows are crisper as the light moves away from the subject, the image will be contrastier.

When many lights are shining into the envelope, they can all cast shadows. Even a reflector can cause shadows. The character and intensity of each light determine whether a shadow is formed. A fill is used to reduce the darkness of the shadows created by the main light. If the fill is a reflector or low-powered diffuse light, it will not likely cause a noticeable shadow. However, if the power of the fill is too great or the reflector is too close, crossing shadows will be created.

As the distance increases the light source becomes less angular.

As with any other light source, a fill light or reflector placed close to the subject produces a more intense light than one positioned farther away. As the fill is moved closer, the light ratio is reduced. The light ratio is increased when the light is moved farther from the subject. Using a flag instead of a fill will also increase the ratio.

The direction of the light produced by the fill is also important in reducing unwanted shadows. If the fill illuminates or reflects purely opposite the main light, the fill light will diminish the shadows in proportion to its intensity. In this arrangement, if the light ratio is 1:1, there will be no visible shadows. At any other position, the fill will add intensity to the main light.

Fills can also affect the color balance of the scene. Without active fill the ambient light within the envelope enters and fills in the shadows. It is not uncommon to see a picture taken with a flash in an environment lit with fluorescent light. Though the areas of the subject lit by the flash will be normal in color, the shadow areas not directly receiving illumination will appear green. This greenish coloration is the ambient fill created by the fluorescent light.

To produce a distinctive shadow pattern a cookie can be used. This accessory is added to the light source or held at a distance from the light depending on the sharpness of the shadow desired. The cookie itself is normally an opaque material with a pattern cut in it. However, there is no requirement that the shadows be crisp or dark. Translucent materials can be used to form the shadows, giving a less intense shadowing. Though typically used to produce shadow, cookies can also be used to introduce a pattern of illumination over part of the light envelope or on the subject.

COMPLEX CONTROL

To this point we have discussed lighting as though it is a single source, single control concept. However, few light envelopes are created with single

controls. The photograph above shows a light envelope that was created for a motion picture. The small area around the two actors in the center of the frame, plus the area around the group of actors in the background, defines the light envelope. The lighting control in the foreground is easier to see. The background illumination is the ambient sunlight with exposure control created by the dark scrim within the red frame.

Few light envelopes are created with single lights and single controls. Photograph by Glenn Rand.

To light the foreground envelope two light sources were used—the sun and an HMI Fresnel. Even though the sky was overcast, a diffuser was used to provide a consistent light angle for the main light. To control the contrast and light ratio of the scene a flag was used to reduce the light intensity on the right side. A Fresnel spot was used to add specular definition. The HMI light was gelled to match the color temperature of the diffused light.

Understanding how to set exposure will provide you with cleaner and more useable images.

EXPOSURE

Whether intensity is added or subtracted, the light is diffuse or specular, or the photograph is taken in a natural setting or a studio, the exposure will take place within the light envelope.

Film and sensors handle the light for exposure differently. Negative films are more tolerant of overexposure but less accepting of underexposure. Image sensors cannot accept overexposure and are noisy in very dark areas of exposure. Understanding how to set exposure will provide you with cleaner and more useable images. Though this might seem more appropriate for a be-

ginning book on photography rather than a lighting book, it is important to remember that it is light that makes exposure happen.

Exposure is capturing the light on the sensor or film. A simple equation defines exposure. This states that exposure (H) is equal to the illumination (E) multiplied by time (T).

$$H = E \times T$$

This means that there are two variables that affect exposure, the illumination and camera controls (aperture and shutter speed). Though it appears that there are only two variables in this equation, there is one other variable (actually, an assumption) that makes the equation work. This is that the film's ISO speed or the digital camera's ISO setting remains constant.

The light establishes exposure as a relationship between the ISO, f-stop, and shutter speed.

The light establishes exposure as a relationship between the ISO, f-stop, and shutter speed. These measures show the impact on the law of reciprocity on photography. In a nutshell, the law states that as one part of the system is increased another part of the system must be decreased to keep the system in balance. At the center of the photographic system is a 2:1 ratio. For instance, the amount of light striking the film or image sensor is either doubled or halved when a one-stop exposure change is made. Changing the aperture setting from f/8 to f/5.6 doubles the exposure, and stopping down from f/8 to f/11 halves the exposure. A shutter speed of one second gives two times the exposure as ½ second. ISO speeds/settings are also based on a 2:1 ratio. An ISO rating of 200 is twice as fast as ISO 100.

The law of reciprocity allows us to produce a series of equivalent exposures by opening up or stopping down and changing the shutter speed setting accordingly. For example, without moving or changing lighting:

> Holding ISO constant, f/4 at ¹⁄₁₂₅, f/5.6 at ¹⁄₆₀, f/8 at ¹⁄₃₀, f/11 at ¹⁄₁₅, etc., all provide the same exposure.

> Holding the shutter speed constant, f/11 at 400 ISO, f/8 at 200 ISO, f/5.6 at 100 ISO, etc., all provide the same exposure.

> Holding f-stop constant, ¹⁄₁₂₅ at 400 ISO, ¹⁄₆₀ at 200 ISO, ¹⁄₃₀ at 100 ISO, etc., all provide the same exposure.

The variability of ISO settings that digital cameras allow offers another way of controlling exposure not available with roll film. Sheet film, however, will allow this approach with push/pull processing.

The three controls provide the photographer with different ways to achieve equivalent exposures (i.e., a series of settings that achieve the same level of exposure). Because f-stops, shutter speeds, and ISOs are based on a 2:1 ratio,

there are many potentials. By holding one of the three controls constant the other two can create equivalent exposures.

This provides further control over exposure. While we can use equivalent exposure when holding the light intensity constant, we can hold the exposure constant while tuning the light. Whether controlling the light's intensity electronically or using the Inverse Square Law, we can tune the lighting to meet an exposure value. This gives us a great deal of control.

As stated above the ratio 2:1 is key to controlling exposure. In practice, this means that when we move the light 1.4 times farther from the subject, the intensity of the light is halved. We are working backwards with the Inverse Square Law, and 1.4 is approximately the square root of the number 2. When a light is moved 1.4 times farther away, there is half the light or a one-stop loss of intensity. If we move the light twice (2x) as far from the subject, we have adjusted the light two stops, and if we move the light 2.8 times farther away we have reduced the light by three stops. This relationship holds true for all full stops as multipliers of distance change for the light.

If we move the light twice (2x) as far from the subject, we have adjusted the light two stops.

METERING

Basic Daylight Exposure. Photographers often use built-in or handheld meters to ensure proper exposure. However, there are times when knowing how to judge the light will arrive at good exposure.

In daylight and ambient light envelopes, you can use a non-metered approach to determining exposure. With the sun, for all intents and purposes, a constant distance from the earth, the light reaching the light envelope will be constant with normal clear sky sunlight. Therefore, we can set a standard for lighting using the sun as our main light.

Basic daylight exposure (BDE), also called the sunny day or sunny 16 rule, allows you to adjust exposures based on a set of recommendations related to the light rather than a meter measurement. The concept is built on the assumption that on a sunny day, an f/16 aperture setting and a shutter speed of $1/\text{ISO}$ can be used to produce a correct exposure. With a shutter speed of $1/\text{ISO}$, the following are recommendations for BDE:

LIGHT CONDITION	LIGHT VALUE	EXPOSURE
Sunny day	BDE	f/16
Sunny on snow or sand	BDE + 1 stop	f/22
Hazy	BDE − 1 stop	f/11
Normal cloudy but bright	BDE − 2 stops	f/8
Overcast or open shadow	BDE − 3 stops	f/5.6
Lighted signs (to see the color)	BDE − 5 stops	f/2.8
Stage lighting (bright stage)	BDE − 5 stops	f/2.8

The following scenarios will require adjusting the shutter speed and f-stop:

Bright city streets (Times Square), fireworks, night football, store windows	BDE – 6 stops	+ 6 stops
Stage lighting (spot lighting), night baseball	BDE – 7 stops	+ 7 stops
Inside schools and churches (well lit)	BDE – 9 stops	+ 9 stops
Flood-lit buildings or neon lights	BDE – 11 stops	+ 11 stops
Distant city	BDE – 13 stops	+ 13 stops

Light Meters. Though determining exposure through BDE is possible, most exposures are determined by light meters. Light meters can be built into the camera or handheld. Reflective meters evaluate the amount of light that is reflected from the subject. Incident meters, on the other hand, are used to determine the amount of light falling on the subject.

Reflective meters are available in two types: averaging or spot meters. An averaging meter reads all the light reflecting toward the meter from the entire light envelope. A spot meter measures the light entering the meter from a specific area within the envelope. Either type may be built into the camera or handheld. A problem with reflected metering occurs when the subject is very light or very dark. This creates subject bias and will cause images of dark subjects to appear overexposed and images of light subjects to look under-exposed. In such cases, an incident meter should be used. Because an incident meter measures the light in the envelope, it is not influenced by subject bias.

Substitution Metering. Subject bias can be avoided by using substitution metering. To use this technique, you use a reflected light meter to meter an object with a known reflectivity (e.g., an 18 percent gray card). The object you are metering must be part of the subject, placed at the subject location in the light envelope, or receiving the same intensity of light as the subject. If the only thing that the metering system measures is the substituted material, the results will match those of an incident meter.

Though a gray card, held perpendicular to the lens axis, is a popular choice for substitution metering, there are other commonly used targets. For instance, you can meter a clear north sky, which has a relative luminance equivalent to 18 percent reflection. You can also measure the light reflected from the palm of your hand, then reduce the exposure by one stop.

Flash Meters and Guide Numbers. When working with electronic flash, photographers typically use a flash meter, which also reads incident light. A

This exposure was made at night and metering was not practical. Using BDE, an exposure was established that allowed for the capture of the color of the lights. Photograph by Glenn Rand.

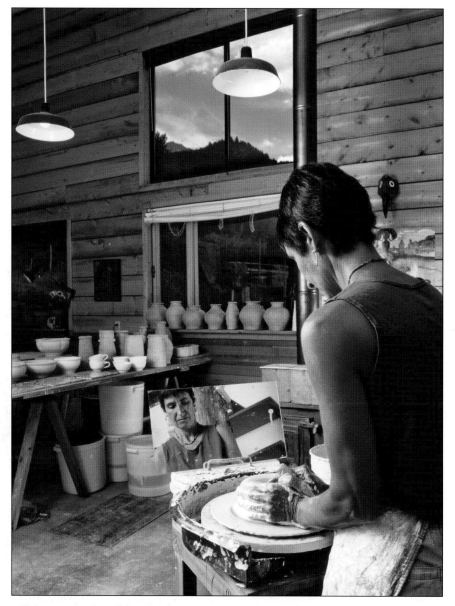

Left—Light balancing was used to produce this image. Since shutter speed is less of an issue for electronic flash, the light outside was balanced to the flash exposure by using an equivalent exposure to set the camera's shutter speed to the f-stop recommended by a flash meter. Photograph by Glenn Rand. **Above**—This photograph was made for *Women's Circle Crochet* magazine. The lighting of this subject was controlled to produce only three stops of difference between the reflected spot-meter readings from the white yarn and the black detail. The lighting was adjusted while taking meter readings until the light was tuned to create the dynamic range required for the magazine's printing. Photograph by Glenn Rand.

still better option for ensuring proper exposure when using electronic flash is to use a guide number (also called a guide factor). A guide number is a value used to calculate the correct f-stop for the flash-to-subject distance and ISO rating/setting required to achieve correct exposure. To determine the correct f-stop, divide the guide number by the distance (the guide number is often provided with the flash unit). To determine the best subject distance, divide the guide number by the f-stop.

Tonal Placement. Tonal placement metering is an important tool to accomplish the desired look in our images. In fact, it is the basis of the Zone System. The concept is built on the direct relationship between stops and zones and holds true for all midtones but loses its effectiveness at the dark and light extremes of the light range. The concept holds that a one-stop change in the light or exposure will change the zone value of the metered area one zone. To use this technique, then, the photographer uses a reflected light

meter to measure the light coming from a selected area of the image. Since the meter is built to calculate exposure of middle gray, opening up one stop will lighten the selected tone to be brighter by one zone and stopping down one stop will darken by one zone. When darkening or lightening any specific area within the image, the tones in the rest of the image will shift in the same direction.

Dark-Tone Metering. Perhaps the most useful and nontechnical approach to film exposure based on the Zone System is dark-tone metering. In this approach, we would determine the area of critical shadow detail in the picture, use a reflective meter to take a reading, then stop down two stops from the recommended setting. In a controlled-lighting scenario, we can take an overall incident meter reading then adjust the fill light in the shadow area to provide a two-stop difference from the metered setting.

Highlight Detail Metering. Highlight detail metering is the flip side of dark-tone metering and is most effective for determining exposure for digital capture and transparency film. In this method, you meter the area in which you want to show highlight detail and adjust the exposure by opening up by two stops.

When darkening or lightening an area within the image, the tones in the rest of the image will shift in the same direction.

Exposure was chosen based on the important highlight tones of the pearl diver. A spot meter was used to take a reading from the diver at a previous surfacing and used for photographing this assent. Photograph by Glenn Rand.

To avoid blooming or blown-out highlights, when working with a tethered system check the histogram for your image and ensure that the maximum highlight value is no higher than 242.

Average Value Metering. Within the light envelope there are generally both highlight and shadow details that the photographer will want accurately presented in the image.

To use average-value metering, use the following steps:

1. Determine the area that requires highlight detail and take a reflected light meter reading.
2. Determine the area that requires shadow detail and take a reading.
3. Choose the f-stop that falls in the middle of the two readings you obtained and use that as the exposure setting. For example, if the highlight area metered f/16 and the shadow metered f/4, you would use f/8 as the exposure setting.

If the distance between the highlight and shadow detail areas of the image is beyond seven stops for film or nine stops for digital, the system will not work well. Note that when the distance is an even number of stops (e.g., f/16 to f/5.8) the average value will be a half stop. In this case, you should select the value below the midpoint for film and the aperture setting above the midpoint for digital work.

SPECIAL CONCERNS FOR DIGITAL EXPOSURES

Testing. Image sensors can only accept a specific amount of light at each pixel. Beyond this point the energy will bloom to adjacent pixels or block up as white. To determine our image sensor's ability to accept overexposure, we must conduct a simple test to determine its exposure index (EI).

To run the test, you will need the following:

1. A meter designed to meter the light in the scene (e.g., an incident light meter; or you can take a reflective meter reading of an 18 percent gray card).
2. A test target that consists of a white, 18 percent gray, and black area that will be large enough on the image to measure in imaging software. These can be overlapped separate cards.
3. A model. The model should be wearing a textured white shirt or sweater. If need be, a piece of white material with heavy texture, ribs, or cabling can be draped over the subject's shoulder.
4. The camera must be in manual mode so that you can adjust the shutter speed and aperture and set it to capture raw files.

To ensure the test is properly conducted, complete the steps on the facing page:

Test setup. Photograph by Tim Meyer.

The camera must be in manual mode so that you can adjust the shutter speed and aperture.

1. Find or create an evenly illuminated scene with an even, solid, dark background. If there is a bright background or backlighting the test will be inaccurate.

2. Place the card(s) on a stand near the model's face. Accuracy will only happen when the gray, black, and white cards are parallel to the sensor's plane (the back of the camera). Also ensure that you can see part of the white fabric with detail.

3. Check to see that the light is non-directional (i.e., diffuse) on the model and card(s). Do not conduct the test under specular light.

4. The ISO for the light meter must be the same as the selected ISO for the camera. (Because of noise considerations it is recommended that you use ISO 100 or the lowest available ISO for baseline testing.)

5. Take an incident meter reading and write down the f-stop and shutter speed.

6. Take a reflective meter reading of the white test patch. Subtract the incident reading (step 5) from the reflected white reading. The resulting value will be used when determining the optimal exposure.

7. Make an exposure with the aperture opened up two stops from the reading obtained in step 5.

8. Close down the lens ⅓ stop and take your second exposure. If your lens has ½ stops, do the test in ½ stops. Record the information obtained for each successive frame.

9. Close down another ⅓ stop (or ½ stop if appropriate) and take another exposure. Repeat until you have a complete four-stop range.

To determine your camera's true ISO, read the white card with the color sampler tool in your image-editing software. Neutralize the file, then take a series of readings across the white card. The neutralizing should not include adjusting the white point. The correct exposure will be the frame where your white card value is approximately 242 with no exposure adjustment.

If you organize the shooting and corresponding white point data in order of exposure, from most exposure to least exposure, you can see which exposure's white point is closest to 242. That is the exposure closest to the ISO

The two examples show a normal exposure (top) and a two-stop overexposure test (bottom). Our task is to find the highest level of exposure in which detail is maintained in the white textured area of the image. Photos by Tim Meyer.

This photograph by Tim Meyer shows the benefit of EI testing a digital camera. The image was captured in JPEG, and without EI testing, shadow details in the background and highlight details in the gown and wall would not have been captured.

set in the meter. The optimal ISO setting (EI) is determined by counting the number of stops (⅓ or ½) from the camera's set ISO. If the EI is below the meter setting, you must reduce your exposure. Conversely, if the EI is greater than the meter setting, you must increase the exposure. Obviously, this is only viable if the camera is used in manual mode using the light meter used for testing. It is also important to record the light meter readings for the white card and the textured white area of the test scene.

Exposure Profiles. An advanced but complicated way to ensure accurate exposure is to build exposure profiles. Because the process is quite complex

and is beyond the scope of this book, this section is designed to merely introduce you to the basic concept.

An exposure profile is an intermediary function that will allow us to work within a changing light environment with predictable results. The profiles include information about the type of light, its intensity range, the camera sensor's limits, the sensor's functional EI, the type of file that will be used, and the limits of the intended output device. As can be imagined, taking into account all these variables and the way they interact can be very difficult.

Right—By establishing your camera's EI, you can ensure that the highlights in your image will not exceed the camera's capture range. Photograph by Glenn Rand. **Above**—The RAW channel histogram shows that few light levels reach the maximum highlight value.

Photograph by Glenn Rand.

Key in developing an exposure profile is the tool in the middle, the light meter. The meter is used to measure light variations, and the values that are calculated are used in the creation of inter-relational and coordinated look-up tables. These look-up tables connect measurements from the light meter, camera limits and processes, and outputs. Each look-up table compares two or more of the variables and provides exposure information based on these or related interactions.

Manually creating exposure profiles is difficult because one must take into account so many interrelated variables. Fortunately, there's a tool that can be put to the task to alleviate this burden. The Sekonic Digital Master L-758DR light meter uses proprietary software and testing tools to calculate exposure profiles, which can then be transferred to the meter via USB connection. Once stored in the memory of the light meter, the profile is accessible as an operating function of the meter. When operated in the profile mode the meter graphically shows the photographer where overall (incident) illumination falls within the dynamic range of the sensor and also indicates if the highlight and shadow points fall outside the dynamic range of the sensor and will be "clipped." This allows the photographer to adjust the lighting or exposure in order to ensure that the photograph can be captured and output as previsualized.

Key in developing an exposure profile is the tool in the middle, the light meter.

5. Adding Dimension

Photographers capture the three-dimensional world on a two-dimensional medium. To create visual excitement in an image, photographers need to create the illusion of shape, volume, and depth in their images. There are various strategies for creating these qualities, and the topic is our focus in this chapter.

SHAPE

Though we can describe an object in terms of its color, size, volume, texture, or other qualities, its shape (i.e., contour) gives us the most information.

In a simple image comprised of a subject positioned in front of a background, we assume the background continues behind the subject (though that area is not visible to us). To understand the relationship between the subject and background, we must be able to see the background and subject as separate and distinct. There are two key ways in which this separation can be achieved: (1) via subject/background contrast; (2) through depth of field.

We must be able to see the background and subject as separate and distinct.

If the shape of the subject is to be seen, there must be sufficient contrast between the subject and the background where the two appear to meet. This can be achieved through color or tone. Of the two potentials for establishing contrast between the subject and background, tonal difference is most effective.

When the boundary appears to be part of the subject and the background, visual confusion may result. This phenomenon is known as contour rivalry or a figure/ground illusion. Often this occurs when the subject and background tones at the boundary are flat with a strong tonal variation, or with the background tones lighter and thus visually advancing. In such cases, the subject/background relationship is inverted.

Rendering a background out of focus and the subject in focus can visually enhance the dimensionality of the subject. Because depth of field is dependent on the lens aperture selected, and the intensity of the lighting can be used to control the selected f-stop, this aspect, too, pertains to lighting. Lower light levels allow for the use of larger apertures and the resultant soft/out-of-focus backgrounds.

An image can be created with the background in sharp focus and the subject blurred. However, in such a case the viewer may perceive the foreground and background as being transposed.

Left—(Top) The contour of the boulder in the foreground is clearly defined with the background being seen as continuing behind the rock subject. The tonal difference, both from light to midtone and dark to midtone, is strong enough to give a distinct contour. Photograph by Glenn Rand. (Bottom) The contour of the face is defined by the contrast of the profile with the light pattern behind the subject. Photograph by Tim Meyer. **Right**—Due to the lighting on the grass, the tone of the grass is approximately the same as that of the clouds near the horizon. The resultant low contrast range makes the contour of the horizon meld with the background, the sky. Photograph by Glenn Rand. **Facing page**—In this image, the lightness of the trees makes the background advance visually, creating a contour rivalry situation. This is particularly the case where the glass is broken out and the broken edge is visible. Photograph by Glenn Rand.

VOLUME

In order to create the perception of volume in an image, we must be sure that the lighting creates a range of tones. The tonal transfer inherent at the delineator is key to establishing the volume of an object; the gradual shift from light to dark creates a feel of dimension that is lacking when an object has a uniform tone. Both very diffuse and extremely specular light can flatten the tones on many surfaces and reduce the appearance of volume.

The surface quality of the object being photographed also affects our perception of volume. Diffuse surfaces will produce the desirable tonal transi-

tions when directional diffuse light or specular light are used. Specular surfaces tend to show volume by how they distort reflected lighting or other objects. When light, whether specular or diffuse, originates from behind the camera or is on axis with the camera, the object will appear flatter.

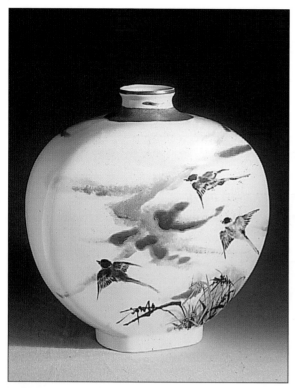

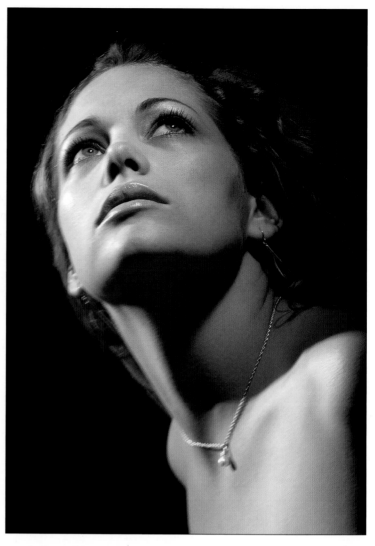

Left—There are several factors at play in sculpting the shape of this vase. Its specular surface reflects the large diffuse light positioned to the right and at camera level. Because the front surface of the vase is curved, the large light's reflection falls off. This accents the bulging front of the object. A white card was placed to the left of the object; the light reflected off of it accents the curve of the side of the vase. Because the subject is primarily white the reflection of the diffused light is not as evident. Though a gradient background is used, the vase is darker than the background at every point. This contrast establishes the contour of the piece. Finally, because the front of the vase is bright, it appears to advance in the image. Photograph by Glenn Rand. **Right**—The diffuse nature of the skin gives subtle tonal transitions that create the perception of volume. The main light coming from the left creates a strong transfer edge and a shadow across the shoulder. The specular highlights also add to the sense of volume. Photograph by Tim Meyer.

DEPTH

Perceptual studies indicate that there are nine ways to create the illusion of depth. Using light, photographers can create the illusion in two ways.

The first way that light can be used to create depth is through the interposition of a shadow falling onto part of the image. If a shadow is to be used to create depth, the relationship between the shadow-casting object and the shadow must be clear to the viewer. When this relationship is unclear, shadows tend to flatten the image. Such flattening can also result when the shadows are very dark. This technique was used extensively in the "Hollywood" era to great effect.

The second way in which we can create a feeling of depth is through the strategic use of color and brightness. Bright elements in a scene tend to advance visually, and dark areas tend to recede. Color vision requires more light than is required to simply perceive brightness. Thus when we see a highly

Renaissance painters realized that three tones were required to create a feeling of depth. The first was the brightness of the object. This established the object in the picture space as well as its lightest value as a subject. To create depth and volume two other tones were needed to modify the object's lightest tone. A brighter highlight value advanced toward the viewer, and darker tonal values appeared to recede.

saturated color our perceptual system interprets more light (brightness). Therefore, saturated colors appear to advance and dull colors appear to recede.

One of the variables at play in ensuring a proper exposure is the aperture setting we will select. Because stopping down or opening up the aperture affects the depth of field, our exposure choices can also affect the appearance of depth in the scene. As mentioned above, a sharp object will seem to advance more than an out-of-focus background.

CASE STUDY 1: LIGHTING FOR VOLUME AND DEPTH

As discussed above, an object's shape is sculpted mainly by creating the desired foreground/background contrast in the scene. To create volume and depth, however, we rely upon the angle of the light. Assuming the light is a positioned at a consistent distance from the subject throughout a series of captures and that its quality remains unchanged, simply moving light(s) in relation to the subject will allow us to control the major effects of lighting.

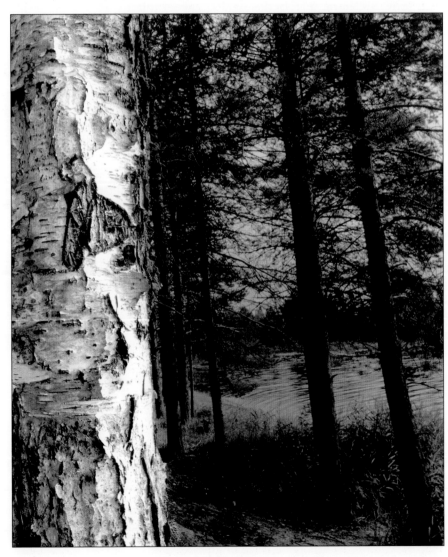

The brightness difference between the birch tree in the foreground and the dark tones in the background accentuates the feeling of depth in the image. The highlight and shadow tones on the bark create depth and roundness because the darker tones recede slightly and the highlight tones advance. Photograph by Glenn Rand.

The main light creates most of the emphasis and enhances our perception of volume and depth. To understand how light effects are created we can think of our subject as being in the center of an invisible dome, with the lights being moved around and above the subject (i.e., following the shape of a dome). Below, we'll look at eleven images that show the effects of moving the main light in relation to the subject. Following these basic setups are eleven more images that employ a fill light in addition to a main light to fill in shadows and further enhance the perception of volume and depth.

Images 1 through 11 (Main Light Only)

1. Front-on, or as near to the camera axis as possible. This is the effect created by an on-camera flash. This is a sterile light that diminishes texture and does not produce additional shape, volume, or depth. Shadows are thrown back into the scene and only have an effect if they fall on a surface behind the subject, being offset from the camera axis showing as a black outline on the side of the subject.

2. Front 45° at the level of the camera. This light is good for objects with strong planar changes, particularly when the changes are vertical. Shadows are long into the background, and the texture of objects is improved. When the texture is on a horizontal surface or vertical surface going away from the light, texture is enhanced. This use of shadows creates the impression of depth.

3. Side at the level of the camera. This position is good for showing off texture on horizontal surfaces perpendicular to the camera. The shadow-

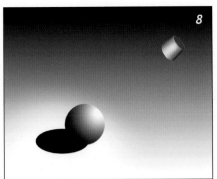

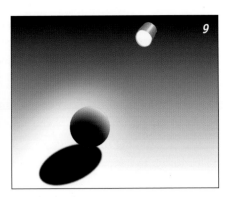

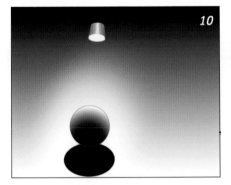

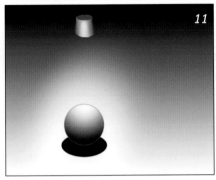

transfer edge created in front of the subject can enhance the apparent volume. Shadows are long and prominent, but as they do not go back into the scene they do not add depth.

4. Rear 45° at the level of the camera. In this position, the light will throw shadows across the scene accentuating the shape of the shadow. The shadow becomes important information about the shape because the objects are starting to silhouette. Camera flare will start to become a problem as the light moves to the rear.

5. Rear at the level of the camera. Objects become silhouetted and flare becomes a problem. Most detail in the object is lost. The contour may be rim lit. The shadow is elongated coming toward the camera. If the light is not totally blocked by the subject, flare will result.

6. Front at 45° angle above the camera. Shadows are thrown down and back into the scene and only have an effect if they spread. The light will tend to flatten shape slightly. Textures will be diminished.

7. Front 45° at 45° angle above horizontal. Good for showing the shape of non-planar objects and excellent for enhancing overall shape and depth. Shadows will become important as they fall on the ground or other objects.

8. Side at 45° angle above horizontal. This lighting pattern produces strong texture on horizontal surfaces with moderate shape rendering.

9. Rear 45° at 45° angle above horizontal. Makes shadow shape very important. Allows some light to spill over objects and creates a moody look. This position is commonly used to produce a hair light effect.

10. Rear at 45° angle above horizontal. Light spills over the subject, accenting the top surface. Textures are reversed if seen and shadows are strong on horizontal surfaces.

11. Directly above the subject. Good for vertical facing texture and shapes with overhanging parts. This is common for glamour lighting.

Images 12 through 22 (Main Light with a Fill Card)

12. Front-on or as near to the camera axis as possible with a fill card. This setup diminishes texture and does little for shape. Shadows have little or no effect in the scene. The fill effect will not be seen.

13. Front 45° at the level of the camera with a fill card. This light is good for objects with strong planar changes particularly when planar changes are vertical. Shadows are short and texture is improved. The fill shows definition in surfaces away from light.

14. Side at the level of the camera with a fill card. The light will accentuate differences between vertical surfaces by lighting the surface facing the light more and illuminating other surfaces less. The fill gives ample light in the shade areas.

15. Rear 45° at the level of the camera with a fill card. The fill becomes the prime light for camera-facing surfaces giving them a diffuse look and casting a shaped shadow in front of the subject.

16. Rear at the level of the camera with a fill card. Detail is seen only because of the fill. If the fill is weak the objects will silhouette. When the fill is moved more to the front, it will function as a front diffuse light and can be used to open up shadows.

17. Front at 45° angle above the camera with a fill card. This setup tends to flatten shapes. Therefore, it is an ineffective lighting pattern for most photography.

18. Front 45° at 45° angle above horizontal with a fill card. Good for shape. This setup, called Open 45° or Rembrandt lighting, is the best gen-

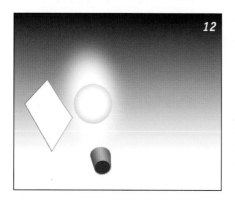

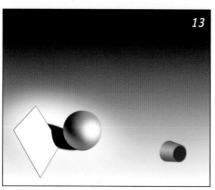

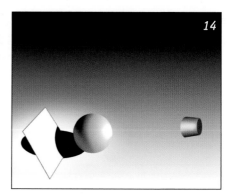

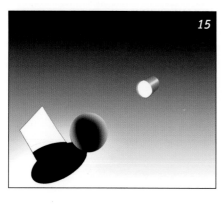

eral lighting pattern for controlled light situations. Shadows will become important if they fall on the ground or other objects. The fill allows for the perception of detail in the shaded areas.

19. Side at 45° angle above horizontal with a fill card. This setup creates half lighting that shows shape. The fill opens up shadows and accentuates texture on all front-facing surfaces.

20. Rear 45° at 45° angle above horizontal with a fill card. This setup allows some light to spill over objects. The fill allows for good definition in front surfaces and softens texture.

21. Rear at 45° angle above horizontal with a fill card. This lighting pattern produces light spills and hot spots. The fill light illuminates front surfaces. Texture is minimized.

22. Directly above the subject with a fill card. Good for vertical facing shapes with overhanging parts. The fill adds light to the shaded areas.

CASE STUDY 2: SIMPLE LIGHTING, NOT SIMPLE LOOKING

Even with simple lighting the results need not look bland. The following images illustrate the way a piece of pottery was lit to create more than a simple representation of the vessel.

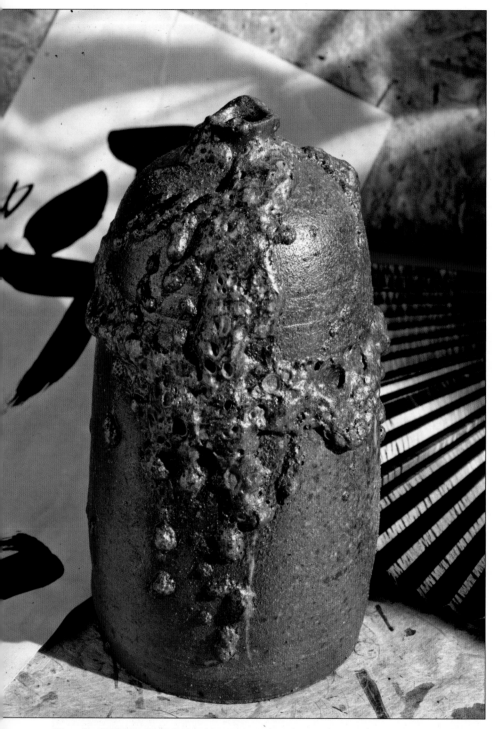

Left—The objective for this assignment was to light the pottery to show its form and texture. Though the lighting was produced with only one light (Open 45°), the effects that were created go beyond a simple lighting effect. Photograph by Glenn Rand. **Right**—(Top) A specular spot was selected to produce good textural effects and to allow the pattern of the fan and the pot to have crisp shadows. This increased the contrast in the image. (Center) A large white fill card was added to bring light into the shadow side of the pottery. This softened the contrast on the subject without decreasing the shadows. (Bottom) Finally, a cookie was used to create shadowing directly behind the pottery and add a light effect to the far background. The darker ground behind the subject accents the contour of the pottery and allows it to advance in the image.

CASE STUDY 3: EXPANDING VOLUME AND FORM

Portrait artists need to show the form of their subject's faces and, at the same time, smooth the subject's skin to minimize the appearance of blemishes. A specular light is typically used to create highlights that will add to the perception of volume. Diffuse light reduces the apparent texture of the skin, thus reducing the appearance of blemishes. The following images show how Tim Meyer approached this challenge.

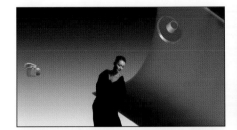

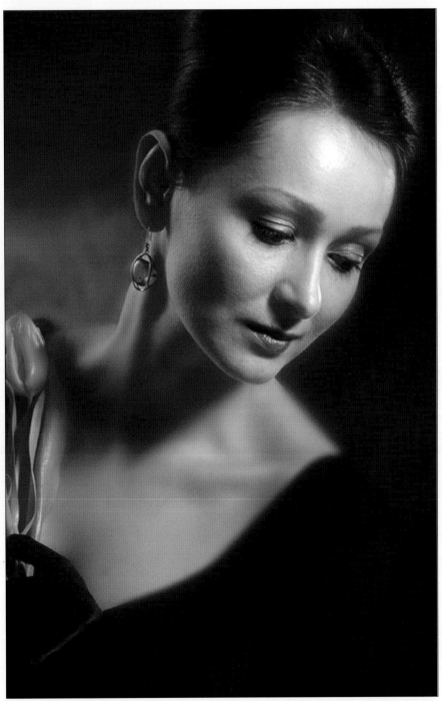

Right—Tim Meyer used a light pattern with an embedded diffuse intensity pattern within a collimated light. The result is a complex specular highlight (the direct diffused highlight blends subtly with the collimated light). Lifting the highlight intensity with the additional light in the light pattern enhances our perception of volume and form. **Left**—(Top) A parabolic reflector flash unit was used as a main light. This unit provided two benefits: It produced a collimated light that is perfect for creating crisp, well-defined shadows with strong shadow transitions. This produced superb definition of the facial features. Second, the unit had a diffusing dome over the flash tube. This diffused some of the highlights, softening an otherwise hard light. The light was positioned high on the side to create the shadow transition coming through the center of the image. This added to the drama of the picture. (Center) A background light was added to give a small amount of illumination to the background to create a strong contour. The light's power was set lower than any other light used. This prevented contour rivalry. (Bottom) A small spot, a "kicker," was added as fill. It was positioned across and slightly off angle from the main light and adjusted to provide the desired lighting ratio, in this case a 4:1 (two stops). Because the fill is not from the camera's position some of the shadows created by the main light remain. These shadows are key in defining volume in the image.

CASE STUDY 4: ACCENTUATING SHAPE AND FORM

Here we will look at the steps used to accentuate shape and volume in our sample subject—a yellow rose presented in a modern acrylic and chrome display piece. The acrylic base allowed some light to come through. The spiral chrome stand was enhanced by being seen against a darker background.

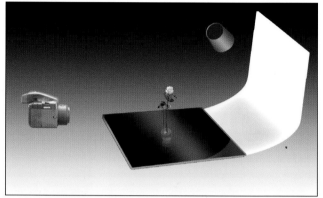

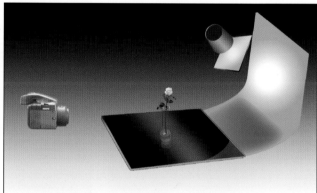

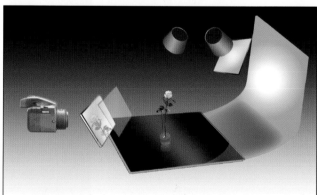

Left—This lighting setup used color fills to reduce color purity and give more separation of the highlight areas and the filled areas of the subject. This deadened the saturation, making the highlights advance and separate from the filled surface or area. The fill that is used is a small mirror, on the front side, below the subject and the complementary color of the part of the subject surface to be deadened. **Right**—(Top) The stand and rose were placed on black shiny acrylic. This allowed the light to be bounced into the set from directly behind the base of the stand, producing a pool of light behind and to the right of the rose. The pool is positioned by moving the light shining on the background until it reflects into the camera from the black acrylic where it is desired. (Center) A light-blue filter was placed in the beam of the background light. Because of the intensity of the light's output, the pool of light still appears white in the center of the light pattern. (Bottom) A spotlight was used to illuminate the flower. The specular light created some contrast in the rose. However, since the rose is light in color, the contrast difference is slight. The light from the spot was reflected by a mirror placed in front of and below the subject. The resultant fill was filtered with a blue filter. Though the spot illuminated the rose with white light, the blue fill light deadened the color in areas it reached, creating more volume in the rose.

6. Highly Reflective Subjects

Whether metal or glass, reflective subjects create problems for the photographer. Though some books offer "cookbook" solutions that will show you how to light a particular object or create a specific look, it is important to understand the principles that govern lighting and learn how to apply them to a wide array of subjects.

Though image editing software can be used to simulate complicated lighting effects, the treatment of the subject must make sense. In order to produce an image that "reads" correctly, you'll need to have a working knowledge of the way light interact with reflective surfaces.

The following sections provide a basic approach to lighting reflective subjects. For more information, see my book *Lighting and Photographing Transparent and Translucent Surfaces* [Amherst Media; forthcoming, 2009]).

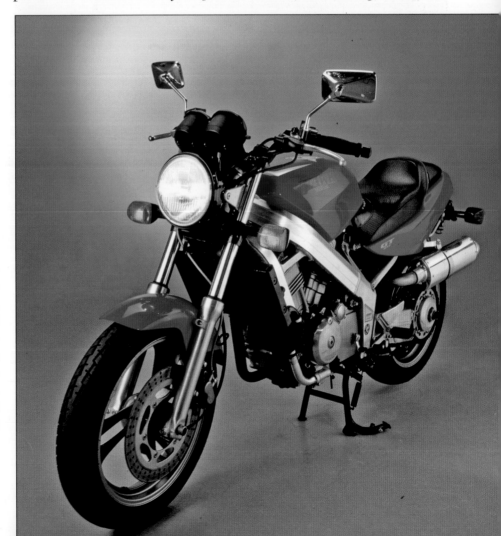

Lighting highly reflective subjects like this motorcycle often requires more equipment and control than it appears. Six spotlights, one softbox, one diffuser panel, and six fill surfaces were used to create this image. Only the softbox was directly lighting the bike. All the spotlights were aimed at the fill surfaces or diffuser. The spotlight shining on the back surface was gelled blue. The headlight and running lights were exposed with separate exposures. Photograph by Glenn Rand.

Left and right—The Law of Reflection states that the angle of incidence equals the angle of reflection. These angles are measured from a perpendicular at the point of incidence. For a curved surface (right), the perpendicular is defined as a line originating at the center of curvature and passing through the incident point. **Below**—Within the image there are both specular and diffuse surfaces, and all are acted on by the same lighting. The metal, china, and plastic are specular, and the cannoli and place mat are diffuse. Though the diffuse surfaces show the affect of the light, the specular subjects reflect the light within the light envelope. Photograph by Glenn Rand.

THE BASICS

When lighting a highly reflective subject, the intensity of the illumination within the light envelope determines how the final image will look. To create a successful image, the photographer must modulate the light within the envelope, controlling not only the way the light illuminates the subject, but also the way the light reflects from it. Some subjects require more lights than would be needed to simply produce an adequate exposure. The additional lights may not illuminate the subject or may be specifically targeted.

As discussed in chapters 2 and 3, there are three main ways that the intensity of the light can be adjusted: by using the controls on an artificial lighting unit, blocking or partially blocking the light, and using the Inverse Square Law.

The optical principle at play when lighting highly reflective surfaces is that the angle of incidence equals the angle of reflection.

On the simplest curvilinear shiny surface, a chrome cylinder, the point of reflection changes as the angle from the camera changes. When viewing the cylinder straight on, the reflection of the camera is seen though reduced. In this case, the camera's viewing angle is perpendicular to the cylinder and the angle of incidence is 0 degrees. There is no reflected angle. With the camera in the same position, there is a 30-degree-tangent angle between the point $\frac{1}{3}$ the way between the front and back of the cylinder and the camera position. The angle of incidence to that point is not the planar tangent angle of the surface but that amount subtracted from 90 (90 − 30 = 60). At this point on the cylinder the camera will view a reflection of any scenic element that appears in a line going behind the cylinder at approximately 60 degrees off axis. Light at this position in the light envelope will be seen on the forward side of the cylinder.

With an understanding of reflection and intensity, we can now apply the single rule that makes lighting shiny surfaces more than happenstance or cookbook: *When photographing a highly reflective surface, don't light the surface; light what is reflected in the surface.*

If the light striking a shiny surface is specular, then the light reflecting off the object will be specular. The light striking a flat surface will reflect to show the shape and type of light. When light strikes a curved surface, the reflection is more compressed and becomes more of a hot spot. The larger the source of the reflection, the larger the reflection on all surfaces. The smaller the diameter of the reflection, the closer it is to becoming a hot spot. If a diffuse, broad reflection is desired on a curvilinear surface, the reflecting source or fill should cover a large angle in relation to the subject.

The smaller the diameter of the reflection, the closer it is to becoming a hot spot.

DETERMINING REFLECTIVE ANGLES

To understand how the camera will capture the reflections on a planar or curvilinear surface, you can place a directional beam of light on the ground glass or against the eye piece of your SLR or view camera and observe the way the light reflects and casts illumination within the light envelope. (*Warning:* laser pointers can be used, but they can cause retinal damage if they shine or reflect into anyone's eyes.) Cards or boards can be used to "catch" the reflecting light and establish the location of reflecting material in the light envelope.

Any light shining onto a highly reflective surface can reflect directly into the camera. If the reflective surface has a lot of curve and distortion and a specular light is directly illuminating it, hot spots (also called *speculars*) will

be unavoidable. This lighting scenario also causes lens flare. Therefore, direct light on a shiny surface should only be used when speculars are acceptable or desired and flare is within the limits of acceptability.

The shape of a curvilinear surface determines where light must be added and reduced in the light envelope. But as mentioned above, these additions and reductions don't happen for lights shining on the subject. A very convoluted shape can cause speculars to be generated by light reflecting within the shape itself.

Transitions from lightness to darkness determine how light will make up the tones and the dynamic look of the reflective surface. If the transition between intensities is abrupt on an open (large radius or planar) surface, the line between the lightness and darkness will be strong. Conversely, if the transition is gradual, the open surface will show a wider transition from highlight to shadow.

The more control you have over potential reflected angles within the light envelope, the better you can control the shape and impact of the elements

within the image frame. Remember that a black element in the scene can visually recede and disappear, and a surface receiving the smallest amount of light can reflect that light and affect the image.

The size of what is reflected also affects the look of the photograph. Both concave and convex surfaces expand what is reflected from the environment. If large reflections need to be created on a surface, then optically large light patterns are required. *Optically large* refers to the angle needed to reflect the light, not to the light's physical size.

Putting the Principles to Work. When photographing highly reflective materials, the camera should remain stationary, ensuring a consistent point if view. This is best accomplished by placing the camera on a tripod or stand.

1. Determine what light pattern is needed to fill a shiny area of your photograph. Use reflective material that is larger than necessary. This will enhance your ability to control the reflective effects. (Repeat this step as often as is necessary.)
2. Determine where light should *not* be in the reflection (you'll typically want to ensure that the reflections do not occur around the camera, but in some cases, this can't be avoided). (Repeat this step as often as is necessary.)
3. Tune the lights to achieve the amount of light desired for specific reflections. Spot meter and fine-tune the setup as necessary. Work on one light/reflection at a time. It's a good idea to turn off all the other lights and viewing the effect through the lens.
4. Determine the best overall lighting and/or directional lighting for the subject. Meter the subject as usual.

BASIC GUIDELINES

- Specular light tends to be more problematic than diffused light.
- Front reflections are produced when the lighting/reflector is positioned straight on.
- Top and side reflections normally require that the lighting material be placed toward the back of the set.
- When adding directional or camera side lighting, be sure that specular reflection is aimed away from the camera and not into the scene.
- Use the shiny surface to add fill in other areas of the image.

Foil streamers were used to add color to a monochromatic subject. The light envelope was created with a large softbox and multiple white cards. A gold fill card was added to the rear of the light envelope creating the warm glow on the front portion of the black Plexiglas. It is also visible in the silverware. Photograph by Glenn Rand.

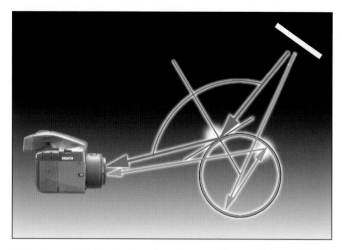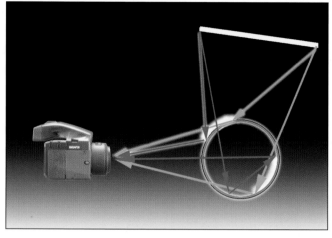

Left—The red light track shown here illustrates the way light would reflect off the outside of a glass cylinder. The blue light track shows how the light passes through the glass reflecting off two surfaces before reaching the camera. **Right**—When the light source gets larger (more diffuse), the light is reflected in larger patterns on both the outer and inner surfaces of the glass. The red arrows show the light path for the front of the source. The blue arrows show the path from the rear of the source. Because the source spreads, the reflections will also show as larger patterns of reflections. This simplified diagram only shows part of the complex refraction and reflection pattern.

GLASS

The way glass transmits light poses a unique challenge. Though there are several standard "cookbook" approaches to lighting glass, understanding the basic nature of light's interactions with the glass will allow you to utilize a wider array of options.

When light strikes a plane of glass, it acts the same as it does when it interacts with any other shiny planar surface: the angle of incidence equals the angle of reflection. However, the angle at which light is reflected from non-planar surfaces (e.g., curved or faceted glass) depends upon the surface's angle to the light, as with other shiny objects.

Another issue that complicates the task of lighting glass is that all surfaces reflect light. This means when light enters a drinking glass, for instance, and strikes an interior surface, it will also reflect in relation to the angle of incidence with the interior surface. Since the interior surfaces reflect light directly and from other interior reflections, the interior surface can create multiple reflections from a single light source.

Though it is easier to see the reflections of specular light, diffuse light follows the same rules. However, diffuse light, because of its broader nature, reflects as large patterns of light on all surfaces of the glass. Light coming from a large bright diffuse source will create larger, brighter, and more intense reflections. A bright reflection on a camera-facing surface will obscure detail or diminish visibility through the glass.

Any light shining onto a glass surface can reflect directly into the camera from both the outside and inside of the glass. When directional light is used, particularly to light a surface that has a lot of facets, curves, and distortions, hot spots are unavoidable. Therefore, direct light should only be used to illuminate glass when speculars are desired.

Any light shining onto a glass surface can reflect directly into the camera.

The second major way in which the light's interaction with glass affects your photography is that the light can pass through the subject. The light passing through rounded or faceted glass reacts the same as light passing through a lens or prism. A specular light shining directly onto rounded or faceted glass will create a pattern of redirected or focused light that may show on other areas visible in the image.

When the light passes through the glass some of its intensity will be decreased by absorption. The more glass the light passes through and the more dense the colorant in the glass, the more absorption takes place and the light loses intensity.

Black Line and White Line Lighting. The principles of reflection and transmission are used to our artistic advantage in creating the two major lighting styles for glass: black line and white line lighting. If there is a bright light on the side and/or on the surfaces closest to the camera, then the lighting is known as *white line*. When the light passes through the glass,

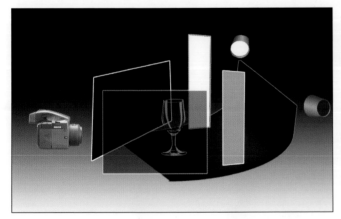

If the reflections on or in the glass are brighter than the background the reflection will show a white line (left). If the background is brighter than the reflections on or in the glass it will show color, tone, and density (a black line; right). Photographs by Glenn Rand.

Left—A classic white-line image is created by placing a vertical fill card on either side and to the rear of the glass. Each card is separately lit controlling the light so that none of the light shines directly on the glass. The farther back the cards are from the glass and the closer to tangent with the surface of the glass the line from the camera to the cards, the closer the lines will appear to the edges of the glass. The narrower the cards and the farther they are from the glass, the thinner the line will appear. The intensity of the light on each card will change the intensity of the reflected line, and even if only one card is used the internal reflections will make it appear that lines appear on both sides of the glass. Flags are angled toward the camera to eliminate reflections on the front surfaces of the glass. **Right**—Using a tight and dark light envelope with only a light background behind the glass creates basic black-line images. If the panel receives light from the front, it should be controlled to prevent direct light from shining on the glass. If the lit panel is too wide, white lines will appear on the edges of the glass. To reduce reflections from the front surfaces, flags are positioned to allow only a small space for the camera to view inside the light envelope. The exposure for black-line images is critical because the camera is facing a light source. If there is overexposure, the tone created by density of the glass will be lost and the dark lines on the edges will be weak.

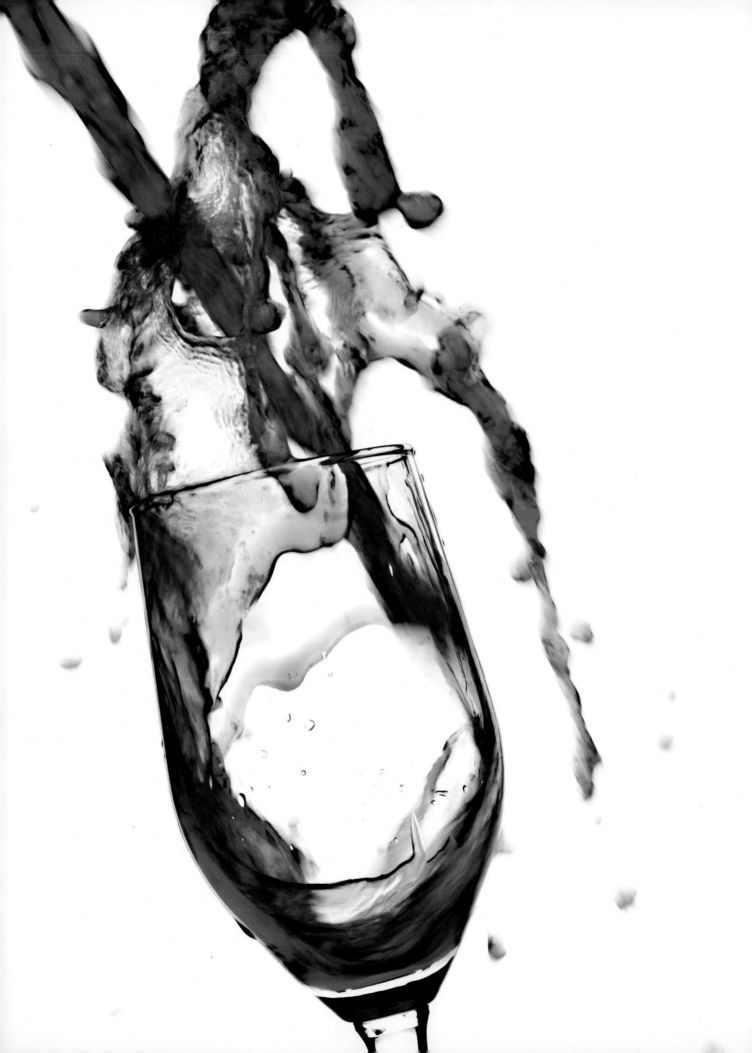

some of its intensity is absorbed by the density of the glass, and there are no reflections on the camera-facing surfaces, a *black line* lighting pattern is created. White line and black line lighting are seldom pure. Normally, part of the lighting will have produce one characteristic and other portions will present the other.

The two forms of lighting are defined by the way the light is seen on the edge of the glass. For this reason, both enhance the perception of the shape of the object. Black line lighting shows color, density, and thickness of the glass or the material in the glass. White line lighting shows the volume of the glass. The lighting styles are most commonly used in combination. Though some photographers use fixed formulas for both types of lighting, there is only one controlling factor in determining which type of lighting showing on any portion of the glass—the background. When the background is brighter than the reflections on the surface of the glass a black line is created. When the reflections on the glass are brighter than the background a white line is created.

Putting the Principles to Work. Use the following steps to approach lighting for glass subjects.

Choose the Lighting Type. When the most important subject in the scene is glass, establishing how the light will be handled must be your first consideration. When the glass is a secondary element in the image, you must define how it will support the rest of the image then light it to best effect.

Since the background plays a key role in determining the lighting style, selecting the backdrop is a primary consideration. Remember that even in a complicated setup, the background can be lit or darkened to set the stage for the desired lighting style.

Establish the Lighting. If black line lighting is chosen, only the part of the background that is directly behind the subject need be considered. The distance between the rear of the glass and the background is not as important as ensuring that light can get to and reflect from the surface or be diffused by it. It is not uncommon for photographers to attach reflective or diffusing surfaces to the back surface of the glass. This allows the glass to be placed in front of other objects without losing the black-line effect.

For white-line images, the light on the background must be less intense than reflections from the glass. Increasing the intensity of the light used to create the reflections can ensure this requirement is met.

Too often reflections are created by using available light fill cards of the wrong size or shape. Remember that the size and shape of your fills can, and should, be customized to suit your needs. Also, the intensity of the lights striking the fills or background as well as the position of the lights and fills can be tweaked to produce the desired lighting effects.

Remove Unwanted Reflections. Removing unwanted reflections will make the photograph. These unwanted light effects can be eliminated by strategically using flags to block portions of the light.

The two forms of lighting are defined by the way the light is seen on the edge of the glass.

Set the Exposure. Spot metering is most helpful for lighting glass. For black line a spot meter can be used to read through the glass to set the level of exposure of the color or tone of the glass. If the exposure is set to the reading shown on the meter, the glass will be recorded as a midtone. Stopping down will make the glass look darker. Opening up will lighten the tone of the glass. For white line images, the photographer can meter the reflection or the fill card. To create a pure white line or reflection, add three stops exposure to the reading.

When using an incident meter to determine proper exposure for a white-line image, point the dome of the meter at the light from the fill card. An incident meter is not as useful for a black-line pattern. However, it can be used to measure the light behind the glass and in front of the background showing through the glass, helping you to make educated decisions when adjusting the light.

BASIC GUIDELINES

- Specular light tends to be more problematic than diffused light.
- Front reflections need camera side lighting material.
- Top (rim light) and side (white-line) reflections require lighting material farther back than the glass.
- The finer the white light desired, the smaller the reflectors that are used.
- When adding directional or camera-side lighting be sure specular reflections point away from the camera and not into the scene.
- Flags are needed to reduce unwanted reflections that may be seen in the glass or obscure detail.

Equipment

POWERING UP SAFELY

Whether in-studio or on location, the availability to power your lights—or, as is sometimes the case, the lack of power—will often dictate your lighting options for your photography. In the studio the wall outlets provide power, and the current your equipment draws can stress the wiring and the overall electrical system for the studio. On location you may need generators or battery powered lights. No matter what power options you have at your disposal, you'll need to keep your safety, and the well-being of any clients, subjects, or assistants, in mind. Be sure to read all of your equipment's operational manuals and ensure that you use your equipment as recommended by the manufacturer.

Here are some specific cautions regarding some common equipment:

• Continuous light units and in some situations electronic flash units require their own designated circuits. Electronic flash units are often equipped with quartz-halogen bulbs, which are used as modeling lights. These bulbs require a significant draw of electrical current.

• The computers used for image editing should be on separate circuits with surge protection. A failure of or spike in the current powering a computer's microchip can cause damage not only to the computer but to the camera—and the effects could be farther reaching than lost images.

Read your equipment's operational manuals and use your equipment as recommended.

LIGHTS

There are a wide variety of light units, all with varying characteristics, available to photographers. In the paragraphs that follow, we'll look at some of the design considerations to gain a better understanding of the available options.

When developing light units, designers are concerned primarily with light duration, quality, and flexibility. In using the lights to create our images, there are additional aspects we must consider: our ability to control the source, the quality of the light produced by the unit, and the heat a unit outputs.

Design and Control. When we speak of lighting, we use the term *control* to refer to our ability to direct light, as desired, onto an area of the scene or subject. To control the light, we can change the position of the light, its proximity to the scene or subject, or its angle to the scene or subject. We can also

use its power settings to alter its intensity. We can also use tools (e.g., a reflector or mirror) to bounce the light coming from a light unit onto another area or to limit the spread of light (e.g., using a grid or snoot) as desired. We can also fully or partially block light to control its effects on our scene.

Many artificial light units are nestled inside of metal housings. This bowl-shaped device surrounds the bulb on three sides and directs the light out of the opening. This is the most common method used for designing light equipment. When a broad coverage of light is desired, a unit in which the bulb is near the lip of the housing is optimal. Another option is a light housing without sides. When a light unit's bulb is positioned deep within the housing, there is a narrower spread of the light.

When the light housing is concave, the light becomes more focused. The focus point is dependent on the distance the light source is from the concave surface and the distance the beam is projected. If the concave is parabolic and the light source is at the mathematical focus of the parabolic surface, the light will come out as a column (i.e., with little or no spread in the beam). When the concave surface is part of a sphere the light will have an amount of spread in its beam. If the light manufacturer desires to have the light be a constant beam the bulb will be at a fixed distance from the concave surface. The bulb's distance from the concave surface will be changeable if various illumination patterns are desired.

The large searchlights that announce the opening of a new store or show are highly reflective parabolic reflectors with the light source at the mathematical focus of the parabolic surface shining back at the reflector creating the column of light. The Broncolor Hazylight employs the same principle. The unit's flash tube is designed to shine toward a parabolic reflector, which directs the light toward a diffusing screen, creating a slightly softer, directional quality of light.

The two forms of lighting are defined by the way the light is seen on the edge of the glass.

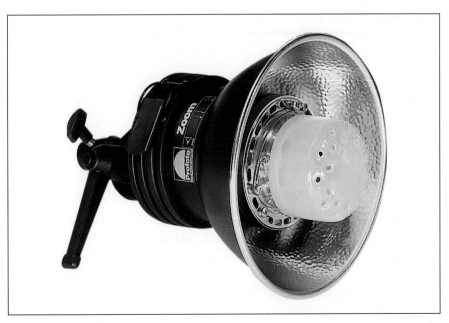

A diffuser dome over the flash tube and modeling light of this lighting unit. Since the distance between the reflector and light source is variable, the beam has a zooming ability. Courtesy of Profoto/MAC Group.

Above—This floodlight's open bulb and open reflector create a broad light pattern. Courtesy of Lowel-Light Manufacturing, Inc.
Right—Some units allow photographers to "focus" the beam of light by varying the distance of the bulb from the reflector. Courtesy of Lowel-Light Manufacturing, Inc.

In some cases, however, reflectors can be added as needed. Most electronic flash heads are equipped with a mounting ring on the base of the unit that allows for the attachment of various reflectors and/or other modifiers. A diffusing dome can be placed over the flash tube to create a softer light quality. A specular highlight will be created if there is no diffuser over the flash tube. Other reflectors, depending on their size, shape, and reflecting surface, can be used to create beams of light of various shapes and sizes.

Another concern in the design of light equipment is the quality of light coming from the source. A bare bulb light, also called a point source light, allows for no directional control. The smaller the light source, the smaller the point source becomes. Because the light is allowed to radiate in all directions, it is very specular and creates sharp shadows at any distance. If the light is close to the subject, the shadows created will have a tendency to spread as they go away from the light. Because of their small size, on-camera flashes exhibit these characteristics.

The simplest floodlight is built when the light source is placed in front of a reflector without side control. The light radiates from the bulb and is bounced by the reflector creating a broad, relatively even pattern of light. Some floodlights are manufactured with the bulb in a fixed position. Other units are built to allow the photographer to vary the distance of the bulb in relation to the curved reflector; this allows the user to vary the size of the light pattern. Incandescent floodlights use lenses as part of the structure of the glass envelope to spread the light.

Some lighting units contain one or more lenses that can be used to focus the light. It is common for the light source (the bulb) to be mounted with a

concave mirror behind the source. Either another mirror or a coating on the bulb reflects the light into the concave mirror. The light then travels through the lens of the light unit. The whole bulb/mirror assembly moves in relation to the light's lens system. This is less complex and still gives the desired focused or collimated light. Fresnal spotlights typically use this construction to create various collimated light patterns.

Similar to a household lightbulb, the flash tube or bulb in lighting equipment can be diffused. For flash units, this is often accomplished by placing a translucent or textured dome over the light. The surface of incandescent bulbs used in floodlights is usually textured or coated. This changes the highlight structure of the flash unit. For example, a diffused source used with a parabolic reflector will produce a more diffused highlight rather than a specular reflection if the diffusing dome is not used.

Another major concern in designing (and using) lighting units is the heat they generate. Incandescent light sources, like the modeling lights in electronic flash units, can generate a great deal of heat. Therefore, manufacturers must ensure proper air circulation. This need is typically addressed by ensuring adequate air circulation. For this reason, light units are often manufactured with holes, fins, and in some cases, fans, that allow air to move through the equipment.

Quartz-halogen bulbs are designed to work at high temperatures. The skin temperature of these bulbs typically reaches 1100°F (594°C) and beyond. If any foreign material comes in contact with the surface of a quartz-halogen bulb it can become a heat sink and absorb extra heat at that point. As the heat builds the temperature will exceed the melting point of the quartz glass and the bulb may become deformed or thin. When the bulb becomes deformed, it can lose its contacts and fail to produce light. If the skin of the bulb thins, the bulb may explode. This is obviously a concern for continuous

 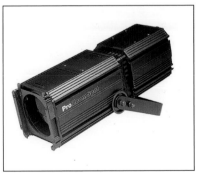 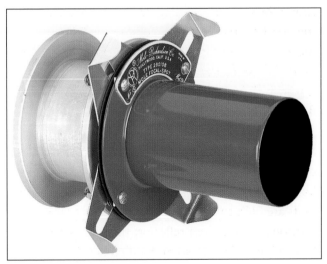

Left—This smaller Fresnel spotlight belongs to a series that ranges from less than 200 to 24,000-watt quartz lights. Courtesy of the Mole-Richardson Company. **Center**—The flash unit is at the back with the focusing unit on the front. Sets of lenses within the front unit are movable, allowing the user to focus the light and adjust the size of the beam. Courtesy of Profoto/MAC Group. **Right**—This spot attachment can be added to a light unit, changing it from a collimated light source to a focused spotlight. Various optics are available to allow different focusing patterns. The design also allows for masks or cookies to be inserted to produce a desired light pattern. Courtesy of the Mole-Richardson Company.

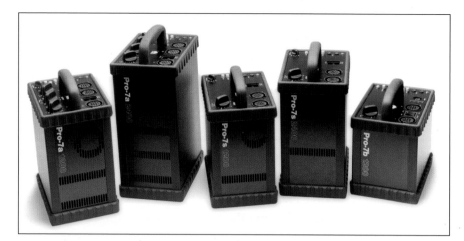

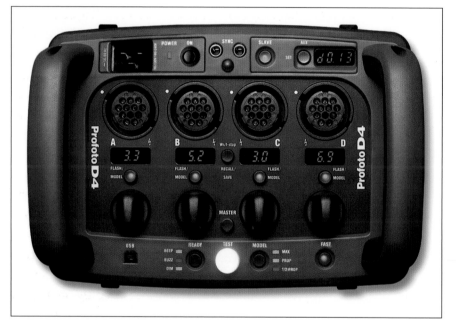

("hot") lights, but quartz lights are also used as modeling lights for many electronic flash units. Needless to say, because of the extreme heat these sources can generate, it is important to exercise caution when changing lightbulbs, even when the bulbs are cool.

Photofloods. Though photofloods do not generate as much heat as the sources discussed above, there is an issue with the use of these bulbs. Because photoflood bulbs do not use an atmosphere that will reunite tungsten molecules shed from the filament, the filament gets thinner. As the filament gets thinner it becomes hotter. This increase in temperature changes the color of the light. The change in temperature and the resultant change in color temperature is the reason why these bulbs have a useful life less than their actual life.

Studio Flash Units. Though continuous lights are normally directly connected to the power source, electronic flash units require a store of power to create the energy surge needed to produce light. A capacitor is used to build up and hold a charge until needed for activating the light. Once the capac-

itor is charged to a desired level, the entire charge can be released at a single moment through the inert gas in the flash tube. Variable capacitors are used to allow the amount of light produced by the flash unit to be adjusted.

Electronic flash units are designed in two basic ways. A monolight is a unit with a self-contained flash head and power supply (these units run on AC power). Studio packs are comprised of a central, capacitor-filled power pack to which individual flash units are cabled. Each flash type has its pros and cons: Monolights tend to output more light than power packs relative to their capacitor size. Because they are self-contained, the units are more portable. Because the power source for studio packs is not contained in the flash unit, larger capacitors can be used—and these produce more power, and consequently, a higher light output. Both designs allow for variable flash output.

In order to activate a flash unit the capacitor's charge must be released into the flash tube. In studio/controlled lighting situations there are three basic ways that this can take place. The first and oldest method is to use a PC cord that connects from the camera (via PC connection or hot shoe) to the flash unit or studio pack. The second method is to use a "slave" that is attached to a flash unit and is activated by a bright flash from another flash. The third way is to use radio or infrared triggers, which send a signal to the flash unit with a receiver that activates the flash.

The flash unit takes a few microseconds to start producing light. This means that there must be synchronization between the flash unit and the shutter in the camera. Though this is not a problem when the camera is equipped with an in-lens leaf shutter, it is a major problem for cameras equipped with a focal plane shutter. In modern cameras the synchronization speed is quite fast, but in older cameras a lack of synchronization can produce unsatisfactory results.

Once activated, the light the flash produces does not stop instantly. However, there are ways to control the length of time the flash tube produces light. Dedicated or auto exposure systems have quenching tubes that can stop light production in the flash unit. This is accomplished by using a thyristor circuit that diverts energy coming from the capacitor when the light energy on a sensor reaches a predetermined level. The sensor measures the light reflecting

Left—The monolight construction has a control unit, the capacitor, flash tube, and an attached reflector. A PC cable or radio/infrared/slave trigger activates the unit. Regardless of the method of triggering, the unit needs to be connected to a power source. Courtesy of Profoto/MAC Group.
Right—The PocketWizard radio transmitter allows for activating electronic flashes without the need for cables. This model allows for multiple flash units that can be activated individually from the master unit as opposed to needing to individually turn each unit on and off. Courtesy of PocketWizard/MAC Group.

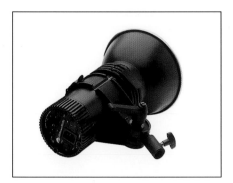

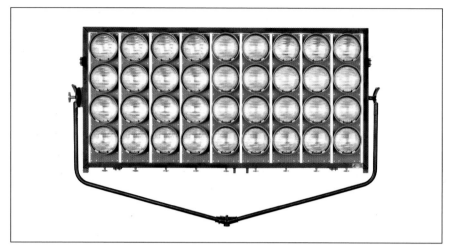

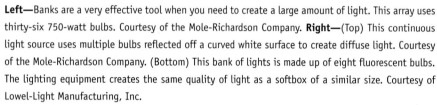

Left—Banks are a very effective tool when you need to create a large amount of light. This array uses thirty-six 750-watt bulbs. Courtesy of the Mole-Richardson Company. **Right**—(Top) This continuous light source uses multiple bulbs reflected off a curved white surface to create diffuse light. Courtesy of the Mole-Richardson Company. (Bottom) This bank of lights is made up of eight fluorescent bulbs. The lighting equipment creates the same quality of light as a softbox of a similar size. Courtesy of Lowel-Light Manufacturing, Inc.

from or on the exposure plane. When the light is diverted a low resistance quenching tube that does not produce light absorbs the energy.

Softboxes. Most commonly, a softbox is an enclosure with a front panel made of light-diffusing material, inside of which a continuous light source or electronic flash head is housed. Softboxes using continuous light commonly create the diffuse light by reflection. These lights come in a variety of shapes and sizes and can be used as a main light or accent light. Because these units are, by definition, part light and part modifier, a discussion on softboxes also appears in the "Modifiers" section below.

Banks. A bank is an array of lights, most commonly of the continuous variety, arranged in close proximity that give both a large amount of illumination and a diffuse light when covering a large angle in relation to the subject.

MODIFIERS

Modifier is a general term used to describe any of a wide array of devices that are attached to or used with a light source to change its qualities, characteristics, or direction.

Softboxes. Perhaps the most commonly used light modifier is the softbox. Softboxes range in size from small collapsible units that can be used on-camera to very large units that require multiple light sources to be able to fully illuminate the diffusing surface. Most softboxes today are made of fabric with semi-ridged spines, allowing manufacturers to produce the modifiers in a wide range of sizes and shapes. Rectangular and octagonal softboxes are most common. Portrait photographers often prefer octagonal softboxes, as the catchlight produced in the subject's eyes will be more circular. Note that black flags can be added to the modifier to customize the shape. For ex-

ample, a circle mask can be applied to an octagonal softbox to creating a round light source for portraiture.

Softboxes typically feature a black fabric exterior, with one side/area made of a white diffusing fabric. This construction blocks the light output from all but the diffuse front surface. The inside of the unit is typically made of a reflective material, usually white or metallic. Higher quality equipment is made of multiple layered materials whether laminated or just lined. The inner surface is designed to reflect the light toward a diffusing screen at the front of the softbox. Quite often a diffusing baffle will be built into the softbox to diffuse the light twice before it exits the softbox.

Because continuous lights output a great deal of heat and softboxes are closed in shape, heat-resistant fabrics are used in the manufacture of softboxes intended for use with hot lights.

Light Tents. Tents are traditionally used to photograph highly reflective materials. A tent is a modifier made of a stiffened or suspended diffuser that creates a light envelope around the subject with only a single opening for the camera. Because the diffuser can be lit from any direction the light envelope will produce light effects and reflections only from the inner surface of the tent.

Many modifiers can be attached directly to or held in front of a light source to diffuse, reduce, or channel the light. Domes or source-mounted diffusers scatter the light at the source. Their effect on the quality of light is deter-

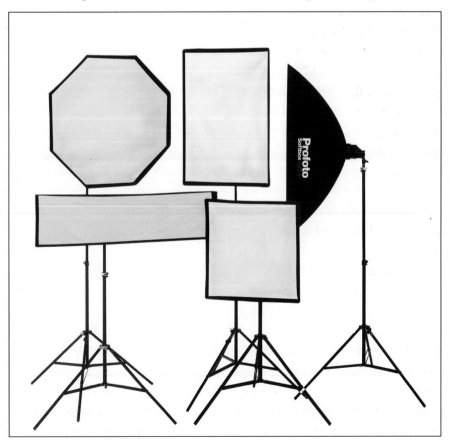

Softboxes are available in various shapes and sizes. Courtesy of Profoto/MAC Group.

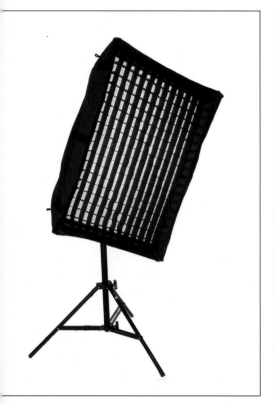

mined by their distance from the subject. Typically, these make the light less specular, but not totally diffuse.

Screens. Metal screens are also used either entirely or partially over the light source and will narrow the beam of light. Screens will produce a small amount of scattering, though not enough to diffuse the light. Because grids and screens are mounted close to the source their pattern will not be evident unless a lens is used to focus or collimate the light. If any are used a weak shadow can be caused by a grid or screen.

Honeycomb Grids. A black metallic hexagonal grid known as a honeycomb is another often-used modifier. The dark metal channels the light into a series of parallel light beams. The depth and thickness of the grid determine the angle of the light's spread. These units are rated in degrees. A grid with a rating of 10 degrees produces a narrower beam of light than one that is rated at 20 or 30 degrees.

Egg Crates. Egg crates are large grids that are attached to the diffuser surface of softboxes or other lights. The egg crates function in a similar way to a grid for the larger light sources. This gives the softbox a more directional feel.

Louvers. Louvers are slanted modifiers that can be attached to a large light source to direct the light. It is important to realize that light modifiers that attach to the source can be seen when photographing highly reflective surfaces.

Snoots. A snoot is a conical or cylindrical-shaped device that is used to narrow the width of the beam of light. Many snoots feature adaptors that allow

The depth and thickness of the grid determine the angle of the light's spread.

the photographer to adjust the width of the beam. The device can also accommodate masks, screens, or cookies.

Cookies. Also known as a cookaloris, a cookie is a solid device with cut-out shapes placed in front of a light to cast a pattern of shadows (or light) on a subject or backdrop. Several companies produce acetate cookies that attach to adjustable stands. This allows the photographer to modify the shadow effects so that they affect the scene precisely as desired. Note that the crispness of the shadow depends on the distance between the cookie, shadow-catching surface, and the light source. Also, the more specular, focused, or collimated the light the crisper the shadow.

Panels. The term *panel* is a bit of a catch-all description used to refer to a range of tools depending on the exact materials used in its manufacture. Panels are made of various materials depending on the function they will serve. Large metal frames covered in white translucent fabric are often used in front of a light source to diffuse the light. A scrim is a large panel covered in a light fabric. A diffuser panel is made using a dense material such as white rip-stop nylon. A reflector is a panel covered with a metallic material. If the reflector panel is flat, it will have one type of reflection, but some panels allow distor-

Various frames and panels can be used to control the light. Black panels can be used as gobos or flags, translucent panels are used as diffusers, metallic panels reflect light and are used as fills or color reflections, and clear frames and panels are used to hold cookies or masks. Courtesy of Chimera.

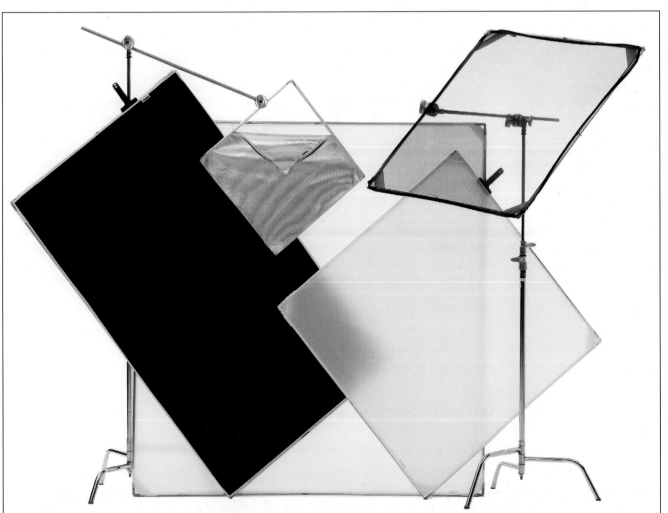

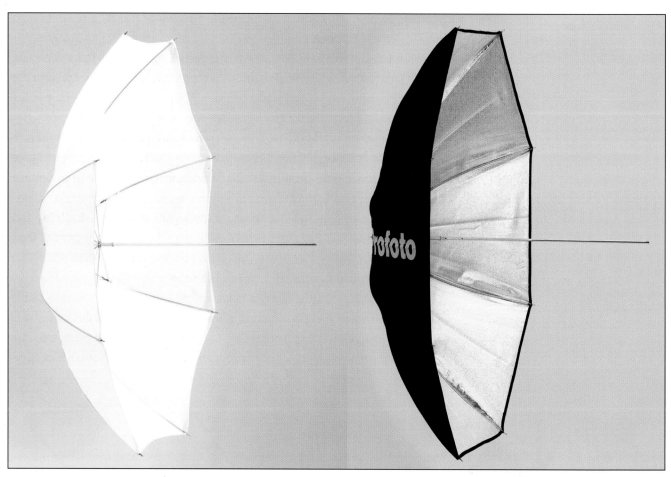

The umbrella on the left is made of white translucent fabric. The light is aimed directly through the umbrella, creating a diffused light dome. The device on the right is a reflecting umbrella. This umbrella has a metallic interior for maximum reflection. Its black exterior eliminates light scatter from the back of the umbrella. Courtesy of Profoto/MAC Group.

tion of the panel to give a slightly concentrating effect on the light reflecting from the panel.

Umbrellas. An umbrella is a simple, concave light modifier typically used to reflect light from a flash (or other bulb source), producing a larger source of light. The inner surface will be made of highly reflective white or metallic (silver or gold) material. To control light scatter, the outside of a reflective umbrella is coated with or manufactured with black material. The positioning of the light shining into the umbrella controls the size of light pattern and the amount of falloff of the light at the edges of the pattern. This is important because the light from the falloff area of the pattern is very useful for creating subtle lighting.

Some umbrellas are made of white fabric and used as a diffused light dome.

Some umbrellas are made of white fabric and used as a diffused light dome. The closer the light source to the transmission umbrella, the more specular the light coming from the equipment.

Mirrors. Mirrors, of course, make excellent reflectors. Mirrors come in many sizes and qualities. The simple makeup mirror with its gimbal base works well since it is small enough to be easily handled. Even smaller and

just as adjustable are mirrors designed for use in automotive repair. These small mirrors are mounted on the end of a rod with an adjustable ball-in-socket connector allowing the mirror to be positioned in any direction. Plexiglas "mirrors" are a useful alternative, as they can be cut to shape and are lightweight and shatterproof.

Cards. Cards of various types can be used as reflectors, gobos, or flags. These may be white, black, gray, or colored. Many photographers use black cards as flags to block light and increase light ratios. Textured black cards can be used to reduce reflections in a scene. White cards are often used to bounce light into a scene and reduce light ratios. Oftentimes, photographers use cards with one black side and one white side, allowing for maximum flexibility and portability. Gray cards can be used to produce a fill effect that is gentler than that created using a white card. Colored cards, though used less often, can be used to creatively affect the color in the scene.

Lens Hoods. Lastly, a piece of equipment that is often forgotten but is perhaps the single most useful in any photographer's tool box is a lens hood. Whether you use a specifically designed lens hood or an adjustable matte box, ensuring that extraneous light from the scene does not enter your lens improves image sharpness, contrast, and color saturation.

Cards of various types can be used as reflectors, gobos, or flags.

About the Author

D r. Glenn Rand has taught and administered in public education, community colleges, and universities since 1996. Since 2001 he has taught in the graduate program at Brooks Institute in Santa Barbara, CA, where he serves as acting graduate program chairman. In conjunction with these academic roles and consulting he has developed and reorganized several curricula for fine art photography, commercial photography, digital imaging, and allied curricula. His teaching has included courses in lighting, as well as commercial and fine art photography.

He received his bachelor's degree and master of arts from Purdue University. He earned a doctorate from the University of Cincinnati, centering on the psychology of educational spaces, and did post-doctoral research as a visiting scholar at the University of Michigan. Since the early 1980s, his extra-academic research has included computer-based imaging.

As a consultant, Rand's clients have included the Ford Motor Company, Photo Marketing Association International, the Ministry of Education of Finland, and many other businesses and several colleges. As part of his consulting for the Eastman Kodak Company, he traveled and lectured on how to maximize Tmax films when they were first released.

Above and facing page—Photographs by Glenn Rand.

Black & white photographs by Glenn Rand are held in the collections of thirty public museums in the United States, Europe, and Japan and are widely exhibited. His photographs have also been used for editorial, illustrative, and advertising functions.

He has published and lectured extensively about photography and digital imaging, covering topics ranging from commercial aesthetics to the technical fine points of lighting. He is the author of numerous books and contributes regularly to various periodicals, such as *Rangefinder* magazine, of which he is a contributing editor. He is the author of two other Amherst Media titles, *Film & Digital Techniques for Zone System Photography* (2008) and *Lighting and Photographing Transparent and Translucent Surfaces* (forthcoming; 2009).

Contributors

Andrea Bachand Meyer. Andrea Bachand Meyer is a professional photographer who has traveled the world in search of history, art, diverse cultures, and challenging topography—or maybe it's just plain wanderlust. She holds a bachelor of arts in art history, literature, and music. Andrea has worked in the photographic industry for over twenty-five years.

Aaron Corey. Originally from Dayton, OH, Aaron received his bachelor of fine arts degree in photographic illustration from the Rochester Institute of Technology in 2002 and studied for a master of science degree in photographic technology at Brooks Institute in Santa Barbara, CA. Aaron has previously worked as a freelance photographer in South Florida. Following the successful completion of his thesis, he plans to continue photographing his personal work and pursue a teaching career.

Cynthia Lespron. Cynthia Lespron was born and raised in Tucson, AZ, where she began her studies in photography. She graduated from the University of Arizona with a bachelor of fine arts degree in studio art in 2004. In 2005, she continued her education at Brooks Institute. She is currently a graduate student working on her thesis. Cynthia has a great appreciation for photography and will continue to use it in every aspect of her life.

Chris Litwin. Chris Litwin lives in Chicago, IL, where he works in food photography. With a degree in sculpture and a chef for a wife, he focuses most of his efforts on food and product photography and is always seeking new photographic opportunities. He furthered his education in the graduate program at Brooks Institute.

Tim Meyer. After twenty-seven years of success with his portrait/wedding studio, Tim Meyer became the chair of the portrait program at Brooks Institute. Tim has been honored as a Master of Photography, Photographic Craftsman, and Certified Professional Photographer. He received both his BA and MA degrees in photography from California State University–Fullerton. Though a full-time educator, Tim stays active in portrait and wedding photography and is a Fujifilm Talent Team member. He is a columnist whose writings on various topics frequently appear in *Rangefinder* magazine.

Lenka Perutkova. Born in the Czech Republic (when it was Czechoslovakia), Lenka Perutkova has lived in and made photographs in Europe and the United States.

Michael Rand. Educated at the University of Michigan with his master of arts degree from Southern Cross University in Lismore, Australia, Michael has exhibited and had his work collected by museums in the United States. His illustrative and travel photographs have been published in numerous magazines.

David Ruderman. David Ruderman has been making photographs for many years—his interest in black & white photography began fifty years ago. His work accelerated while in the Peace Corps in India where he documented life in a poor part of the country. Through self-study he learned the basics and refined his technique with well-known photographers through short courses and workshops including the John Sexton Workshops. He works in Sacramento, CA, where he exhibits and has his work published. Like many other photographers, David is transitioning to digital photography, though his love and photographic experiences are heavily weighted with his black & white photography.

Patrick Stanbro. Patrick Stanbro spent his youth in Los Alamos, NM, where he discovered his interest in photography through an internship at the Santa Fe Photography Workshops. He graduated with honors from Brooks Institute in September 2003, receiving the Industrial/Scientific department award. For his master's thesis at Brooks Institute, Patrick studied ultraviolet photography beyond the capabilities of glass optics. Patrick's work assisting Dr. Austin Richards with thermal imaging has been featured in several scientific journals. Raytheon's Space and Airborne Systems division currently employs Patrick as a technical photographer.

Index

POSING FOR PORTRAIT PHOTOGRAPHY
A HEAD-TO-TOE GUIDE

Jeff Smith

Author Jeff Smith teaches surefire techniques for fine-tuning every aspect of the pose for the most flattering results. $34.95 list, 8.5x11, 128p, 150 color photos, index, order no. 1786.

PROFESSIONAL MODEL PORTFOLIOS
A STEP-BY-STEP GUIDE FOR PHOTOGRAPHERS

Billy Pegram

Learn to create portfolios that will get your clients noticed—and hired! $34.95 list, 8.5x11, 128p, 100 color images, index, order no. 1789.

THE PORTRAIT PHOTOGRAPHER'S GUIDE TO POSING

Bill Hurter

Posing can make or break an image. Now you can get the posing tips and techniques that have propelled the finest portrait photographers in the industry to the top. $34.95 list, 8.5x11, 128p, 200 color photos, index, order no. 1779.

MASTER LIGHTING GUIDE
FOR PORTRAIT PHOTOGRAPHERS

Christopher Grey

Efficiently light executive and model portraits, high and low key images, and more. Master traditional lighting styles and use creative modifications that will maximize your results. $29.95 list, 8.5x11, 128p, 300 color photos, index, order no. 1778.

STUDIO LIGHTING
A PRIMER FOR PHOTOGRAPHERS

Lou Jacobs Jr.

Get started in studio lighting. Jacobs outlines equipment needs, terminology, lighting setups and much more, showing you how to create top-notch portraits and still lifes. $29.95 list, 8.5x11, 128p, 190 color photos index, order no. 1787.

DYNAMIC WILDLIFE PHOTOGRAPHY

Cathy and Gordon Illg

Taking wildlife pictures that will impress today's savvy viewers requires a lot more than just a good exposure. Learn how to add drama and emotion to create "wow!" shots. $29.95 list, 8.5x11, 128p, 150 color photos, index, order no. 1782.

DIGITAL INFRARED PHOTOGRAPHY

Patrick Rice

The look of infrared photography has long made it popular—but with digital it's easy too! Add digital IR to your repertoire with this comprehensive book. $29.95 list, 8.5x11, 128p, 100 b&w and color photos, index, order no. 1792.

INTO YOUR DIGITAL DARKROOM STEP BY STEP

Peter Cope

Make the most of every image—digital or film—with these techniques for photographers. Learn to enhance color, add special effects, and much more. $29.95 list, 8.5x11, 128p, 300 color images, index, order no. 1794.

LIGHTING TECHNIQUES FOR FASHION AND GLAMOUR PHOTOGRAPHY

Stephen A. Dantzig, PsyD.

In fashion and glamour photography, light is the key to producing images with impact. With these techniques, you'll be primed for success! $29.95 list, 8.5x11, 128p, over 200 color images, index, order no. 1795.

WEDDING AND PORTRAIT PHOTOGRAPHERS' LEGAL HANDBOOK

N. Phillips and C. Nudo, Esq.

Don't leave yourself exposed! Sample forms and practical discussions help you protect yourself and your business. $29.95 list, 8.5x11, 128p, 25 sample forms, index, order no. 1796.

PROFITABLE PORTRAITS
THE PHOTOGRAPHER'S GUIDE TO CREATING PORTRAITS THAT SELL

Jeff Smith

Learn how to design images that are precisely tailored to your clients' tastes—portraits that will practically sell themselves! $29.95 list, 8.5x11, 128p, 100 color photos, index, order no. 1797.

PROFESSIONAL TECHNIQUES FOR BLACK & WHITE DIGITAL PHOTOGRAPHY

Patrick Rice

Digital makes it easier than ever to create black & white images. With these techniques, you'll learn to achieve dazzling results! $29.95 list, 8.5x11, 128p, 100 color photos, index, order no. 1798.

DIGITAL LANDSCAPE PHOTOGRAPHY STEP BY STEP

Michelle Perkins

Using a digital camera makes it fun to learn landscape photography. Short, easy lessons ensure rapid learning and success! $17.95 list, 9x9, 112p, 120 color images, index, order no. 1800.

MARKETING & SELLING TECHNIQUES FOR DIGITAL PORTRAIT PHOTOGRAPHY

Kathleen Hawkins

Great portraits aren't enough to ensure the success of your business! Learn how to attract clients and boost your sales. $34.95 list, 8.5x11, 128p, 150 color photos, index, order no. 1804.

ARTISTIC TECHNIQUES WITH ADOBE® PHOTOSHOP® AND COREL® PAINTER®

Deborah Lynn Ferro

Flex your creativity and learn how to transform photographs into fine-art masterpieces. Step-by-step techniques make it easy! $34.95 list, 8.5x11, 128p, 200 color images, index, order no. 1806.

MASTER GUIDE FOR UNDERWATER DIGITAL PHOTOGRAPHY

Jack and Sue Drafahl

Make the most of digital! Jack and Sue Drafahl take you from equipment selection to underwater shooting techniques. $34.95 list, 8.5x11, 128p, 250 color images, index, order no. 1807.

DIGITAL PHOTOGRAPHY BOOT CAMP

Kevin Kubota

Kevin Kubota's popular workshop is now a book! A down-and-dirty, step-by-step course in building a professional photography workflow and creating digital images that sell! $34.95 list, 8.5x11, 128p, 250 color images, index, order no. 1809.

PROFESSIONAL POSING TECHNIQUES FOR WEDDING AND PORTRAIT PHOTOGRAPHERS

Norman Phillips

Master the techniques you need to pose subjects successfully—whether you are working with men, women, children, or groups. $34.95 list, 8.5x11, 128p, 260 color photos, index, order no. 1810.

HOW TO START AND OPERATE A DIGITAL PORTRAIT PHOTOGRAPHY STUDIO

Lou Jacobs Jr.

Learn how to build a successful digital portrait photography business—or breathe new life into an existing studio. $39.95 list, 6x9, 224p, 150 color images, index, order no. 1811.

THE BEST OF FAMILY PORTRAIT PHOTOGRAPHY

Bill Hurter

Acclaimed photographers reveal the secrets behind their most successful family portraits. Packed with award-winning images and helpful techniques. $34.95 list, 8.5x11, 128p, 150 color photos, index, order no. 1812.

BLACK & WHITE PHOTOGRAPHY TECHNIQUES WITH ADOBE® PHOTOSHOP®

Maurice Hamilton

Become a master of the black & white digital darkroom! Covers all the skills required to perfect your black & white images and produce dazzling fine-art prints. $34.95 list, 8.5x11, 128p, 150 color/b&w images, index, order no. 1813.

NIGHT AND LOW-LIGHT TECHNIQUES FOR DIGITAL PHOTOGRAPHY

Peter Cope

With even simple point-and-shoot digital cameras, you can create dazzling nighttime photos. Get started quickly with this step-by-step guide. $34.95 list, 8.5x11, 128p, 100 color photos, index, order no. 1814.

MASTER COMPOSITION GUIDE FOR DIGITAL PHOTOGRAPHERS

Ernst Wildi

Composition can truly make or break an image. Master photographer Ernst Wildi shows you how to analyze your scene or subject and produce the best-possible image. $34.95 list, 8.5x11, 128p, 150 color photos, index, order no. 1817.

HOW TO CREATE A HIGH PROFIT PHOTOGRAPHY BUSINESS IN ANY MARKET

James Williams

Whether your studio is in a rural or urban area, you'll learn to identify your ideal client, create the images they want, and watch your financial and artistic dreams spring to life! $34.95 list, 8.5x11, 128p, 200 color photos, index, order no. 1819.

MASTER LIGHTING TECHNIQUES
FOR OUTDOOR AND LOCATION DIGITAL PORTRAIT PHOTOGRAPHY

Stephen A. Dantzig

Use natural light alone or with flash fill, barebulb, and strobes to shoot perfect portraits all day long. $34.95 list, 8.5x11, 128p, 175 color photos, diagrams, index, order no. 1821.

BEGINNER'S GUIDE TO ADOBE® PHOTOSHOP®, 3rd Ed.

Michelle Perkins

Enhance your photos or add unique effects to any image. Short, easy-to-digest lessons will boost your confidence and ensure outstanding images. $34.95 list, 8.5x11, 128p, 80 color images, 120 screen shots, order no. 1823.

THE BEST OF PROFESSIONAL DIGITAL PHOTOGRAPHY

Bill Hurter

Digital imaging has a stronghold on photography. This book spotlights the methods that today's photographers use to create their best images. $34.95 list, 8.5x11, 128p, 180 color photos, 20 screen shots, index, order no. 1824.

PROFESSIONAL PORTRAIT LIGHTING
TECHNIQUES AND IMAGES FROM MASTER PHOTOGRAPHERS

Michelle Perkins

Get a behind-the-scenes look at the lighting techniques employed by the world's top portrait photographers. $34.95 list, 8.5x11, 128p, 200 color photos, index, order no. 2000.

MASTER POSING GUIDE
FOR CHILDREN'S PORTRAIT PHOTOGRAPHY

Norman Phillips

Create perfect portraits of infants, tots, kids, and teens. Includes techniques for standing, sitting, and floor poses for boys and girls, individuals, and groups. $34.95 list, 8.5x11, 128p, 305 color images, order no. 1826.

WEDDING PHOTOGRAPHER'S HANDBOOK

Bill Hurter

Learn to produce images with technical proficiency and superb, unbridled artistry. Includes images and insights from top industry pros. $34.95 list, 8.5x11, 128p, 180 color photos, 10 screen shots, index, order no. 1827.

RANGEFINDER'S PROFESSIONAL PHOTOGRAPHY

edited by Bill Hurter

Editor Bill Hurter shares over one hundred "recipes" from *Rangefinder's* popular cookbook series, showing you how to shoot, pose, light, and edit fabulous images. $34.95 list, 8.5x11, 128p, 150 color photos, index, order no. 1828.

LEGAL HANDBOOK FOR PHOTOGRAPHERS, 2nd Ed.

Bert P. Krages, Esq.

Learn what you can and cannot photograph, how to handle conflicts should they arise, how to protect your rights to your images in the digital age, and more. $34.95 list, 8.5x11, 128p, 80 b&w photos, index, order no. 1829.

MASTER GUIDE
FOR PROFESSIONAL PHOTOGRAPHERS

Patrick Rice

Turn your hobby into a thriving profession. This book covers equipment essentials, capture strategies, lighting, posing, digital effects, and more, providing a solid footing for a successful career. $34.95 list, 8.5x11, 128p, 200 color images, order no. 1830.

PROFESSIONAL FILTER TECHNIQUES
FOR DIGITAL PHOTOGRAPHERS

Stan Sholik

Select the best filter options for your photographic style and discover how their use will affect your images. $34.95 list, 8.5x11, 128p, 150 color images, index, order no. 1831.

MASTER'S GUIDE TO WEDDING PHOTOGRAPHY
CAPTURING UNFORGETTABLE MOMENTS AND LASTING IMPRESSIONS

Marcus Bell

Learn to capture the unique energy and mood of each wedding and build a lifelong client relationship. $34.95 list, 8.5x11, 128p, 200 color photos, index, order no. 1832.

MASTER LIGHTING GUIDE
FOR COMMERCIAL PHOTOGRAPHERS

Robert Morrissey

Use the tools and techniques pros rely on to land corporate clients. Includes diagrams, images, and techniques for a failsafe approach for shots that sell. $34.95 list, 8.5x11, 128p, 110 color photos, 125 diagrams, index, order no. 1833.

DIGITAL CAPTURE AND WORKFLOW
FOR PROFESSIONAL PHOTOGRAPHERS

Tom Lee

Cut your image-processing time by fine-tuning your workflow. Includes tips for working with Photoshop and Adobe Bridge, plus framing, matting, and more. $34.95 list, 8.5x11, 128p, 150 color images, index, order no. 1835.

THE PHOTOGRAPHER'S GUIDE TO
COLOR MANAGEMENT
PROFESSIONAL TECHNIQUES FOR CONSISTENT RESULTS

Phil Nelson

Learn how to keep color consistent from device to device, ensuring greater efficiency and more accurate results. $34.95 list, 8.5x11, 128p, 175 color photos, index, order no. 1838.

SOFTBOX LIGHTING TECHNIQUES
FOR PROFESSIONAL PHOTOGRAPHERS

Stephen A. Dantzig

Learn to use one of photography's most popular lighting devices to produce soft and flawless effects for portraits, product shots, and more. $34.95 list, 8.5x11, 128p, 260 color images, index, order no. 1839.

CHILDREN'S PORTRAIT PHOTOGRAPHY HANDBOOK

Bill Hurter

Packed with inside tips from industry leaders, this book shows you the ins and outs of working with some of photography's most challenging subjects. $34.95 list, 8.5x11, 128p, 175 color images, index, order no. 1840.

JEFF SMITH'S LIGHTING FOR OUTDOOR AND LOCATION PORTRAIT PHOTOGRAPHY

Learn how to use light throughout the day—indoors and out—and make location portraits a highly profitable venture for your studio. $34.95 list, 8.5x11, 128p, 170 color images, index, order no. 1841.

PROFESSIONAL CHILDREN'S PORTRAIT PHOTOGRAPHY

Lou Jacobs Jr.

Fifteen top photographers reveal their most successful techniques—from working with un-cooperative kids, to lighting, to marketing your studio. $34.95 list, 8.5x11, 128p, 200 color photos, index, order no. 2001.

CHILDREN'S PORTRAIT PHOTOGRAPHY
A PHOTOJOURNALISTIC APPROACH

Kevin Newsome

Learn how to capture spirited images that reflect your young subject's unique personality and developmental stage. $34.95 list, 8.5x11, 128p, 150 color images, index, order no. 1843.

PROFESSIONAL PORTRAIT POSING
TECHNIQUES AND IMAGES FROM MASTER PHOTOGRAPHERS

Michelle Perkins

Learn how master photographers pose subjects to create unforgettable images. $34.95 list, 8.5x11, 128p, 175 color images, index, order no. 2002.

STUDIO PORTRAIT PHOTOGRAPHY OF CHILDREN AND BABIES, 3rd Ed.

Marilyn Sholin

Work with the youngest portrait clients to create cherished images. Includes techniques for working with kids at every developmental stage, from infant to preschooler. $34.95 list, 8.5x11, 128p, 140 color photos, order no. 1845.

MONTE ZUCKER'S
PORTRAIT PHOTOGRAPHY HANDBOOK

Acclaimed portrait photographer Monte Zucker takes you behind the scenes and shows you how to create a "Monte Portrait." Covers techniques for both studio and location shoots. $34.95 list, 8.5x11, 128p, 200 color photos, index, order no. 1846.

DIGITAL PHOTOGRAPHY FOR CHILDREN'S AND FAMILY PORTRAITURE, 2nd Ed.

Kathleen Hawkins

Learn how staying on top of advances in digital photography can boost your sales and improve your artistry and workflow. $34.95 list, 8.5x11, 128p, 195 color images, index, order no. 1847.

LIGHTING AND POSING TECHNIQUES FOR PHOTOGRAPHING WOMEN

Norman Phillips

Make every female client look her very best. This book features tips from top pros and diagrams that will facilitate learning. $34.95 list, 8.5x11, 128p, 200 color images, index, order no. 1848.

THE BEST OF PHOTOGRAPHIC LIGHTING

2nd Ed.

Bill Hurter

Top pros reveal the secrets behind their studio, location, and outdoor lighting strategies. Packed with tips for portraits, still lifes, and more. $34.95 list, 8.5x11, 128p, 200 color photos, index, order no. 1849.

MASTER GUIDE FOR TEAM SPORTS PHOTOGRAPHY

James Williams

Learn how adding team sports photography to your repertoire can help you meet your financial goals. Includes technical, artistic, organizational, and business strategies. $34.95 list, 8.5x11, 128p, 120 color photos, index, order no. 1850.

JEFF SMITH'S POSING TECHNIQUES FOR LOCATION PORTRAIT PHOTOGRAPHY

Use architectural and natural elements to support the pose, maximize the flow of the session, and create refined, artful poses for individual subjects and groups—indoors or out. $34.95 list, 8.5x11, 128p, 150 color photos, index, order no. 1851.

MASTER LIGHTING GUIDE
FOR WEDDING PHOTOGRAPHERS

Bill Hurter

Capture perfect lighting quickly and easily at the ceremony and reception—indoors and out. Includes tips from the pros for lighting individuals, couples, and groups. $34.95 list, 8.5x11, 128p, 200 color photos, index, order no. 1852.

POSING TECHNIQUES FOR PHOTOGRAPHING MODEL PORTFOLIOS

Billy Pegram

Learn to evaluate your model and create flattering poses for fashion photos, catalog and editorial images, and more. $34.95 list, 8.5x11, 128p, 200 color images, index, order no. 1848.

THE BEST OF PORTRAIT PHOTOGRAPHY

2nd Ed.

Bill Hurter

View outstanding images from top pros and learn how they create their masterful classic and contemporary portraits. $34.95 list, 8.5x11, 128p, 180 color photos, index, order no. 1854.

THE ART OF PREGNANCY PHOTOGRAPHY

Jennifer George

Learn the essential posing, lighting, composition, business, and marketing skills you need to create stunning pregnancy portraits your clientele can't do without! $34.95 list, 8.5x11, 128p, 150 color photos, index, order no. 1855.

BIG BUCKS SELLING YOUR PHOTOGRAPHY, 4th Ed.

Cliff Hollenbeck

Build a new business or revitalize an existing one with the comprehensive tips in this popular book. Includes twenty forms you can use for invoicing clients, collections, follow-ups, and more. $34.95 list, 8.5x11, 144p, resources, business forms, order no. 1856.

ILLUSTRATED DICTIONARY OF PHOTOGRAPHY

Barbara A. Lynch-Johnt & Michelle Perkins

Gain insight into camera and lighting equipment, accessories, technological advances, film and historic processes, famous photographers, artistic movements, and more with the concise descriptions in this illustrated book. $34.95 list, 8.5x11, 144p, 150 color images, index, order no. 1857.